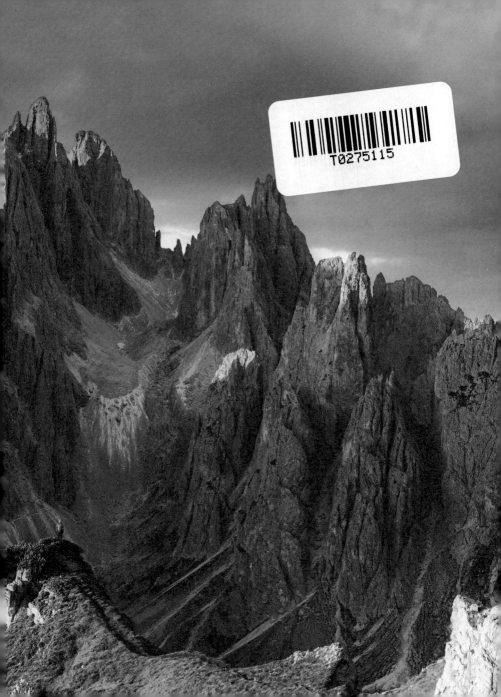

You Are Here

HIKES

THE MOST SCENIC SPOTS ON EARTH

CHRONICLE BOOKS
SAN FRANCISCO

in association with

Blackwell&Ruth.

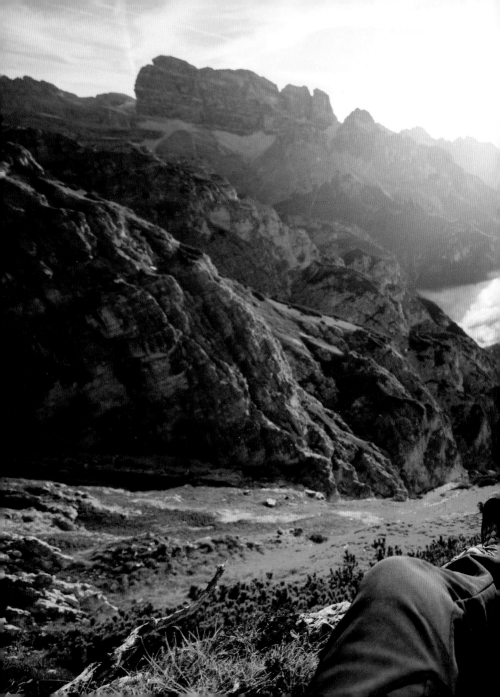

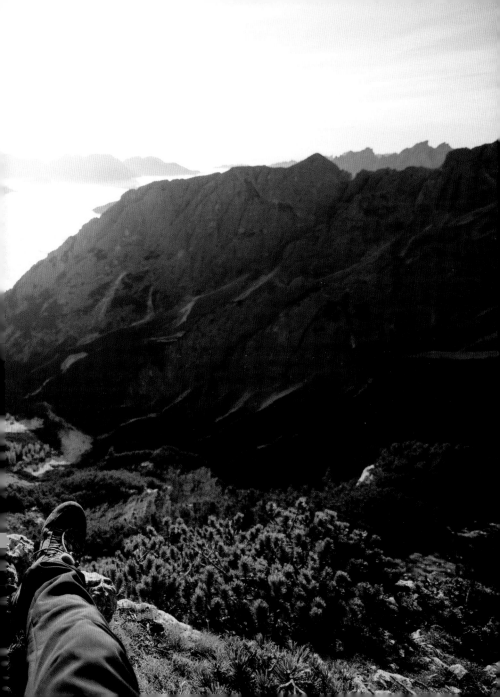

'Look deep into nature, and then you will understand everything better.'

–Albert Einstein

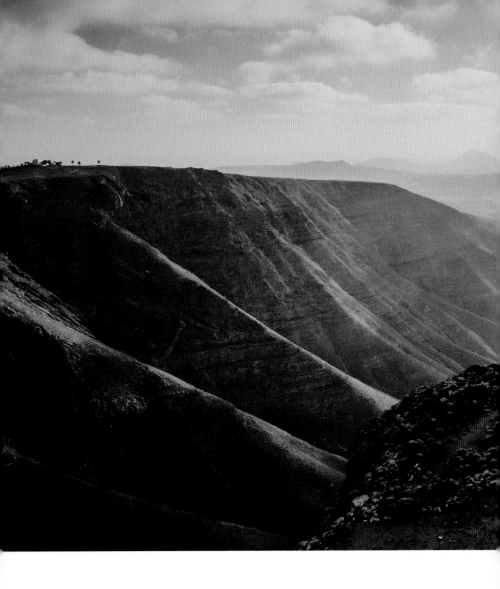

Lanzarote, Canary Islands, Spain
29.0469° N, 13.5900° W

@ABSTRACTAERIALART

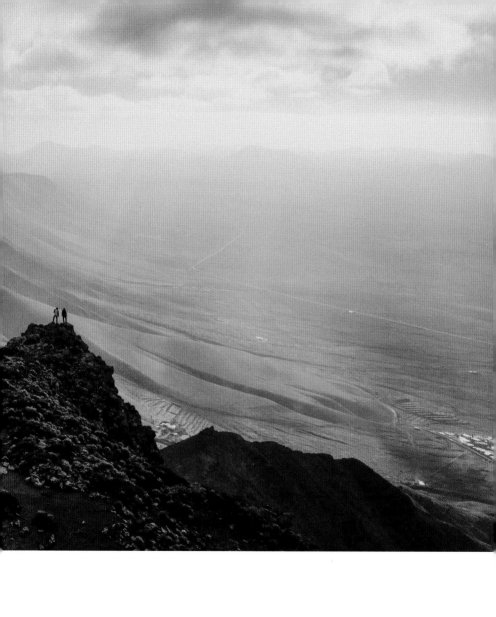

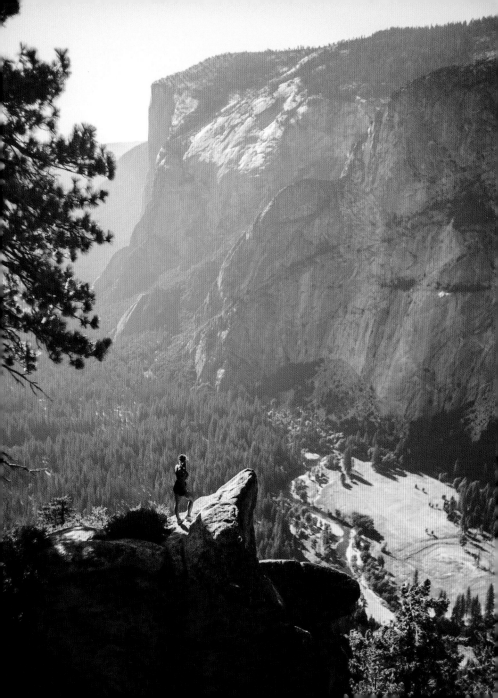

Yosemite National Park, California, USA
37.8651° N, 119.5383° W

Angels Landing, Zion National Park, Utah, USA
37.2690° N, 112.9469° W

ROBERT BOHRER

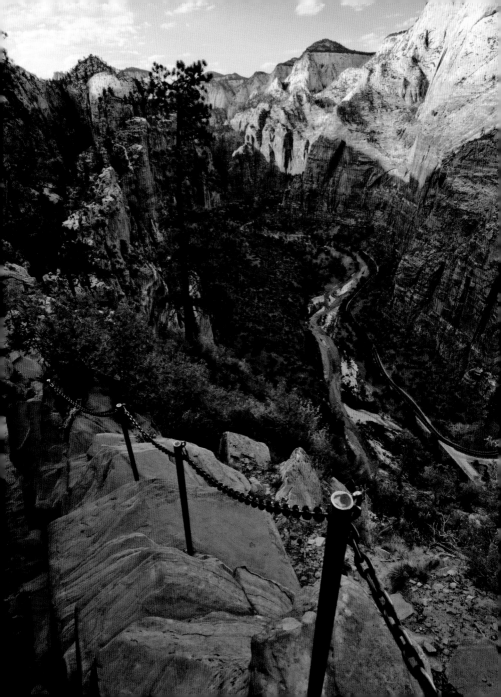

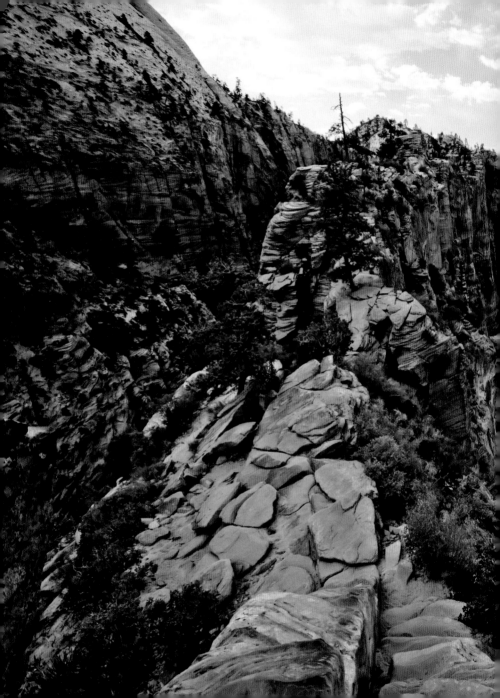

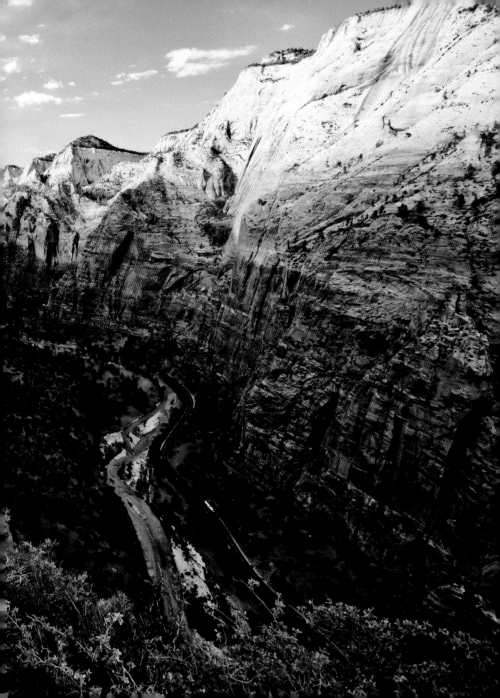

Perito Moreno, Santa Cruz, Argentina
50.4967° S, 73.1377° W

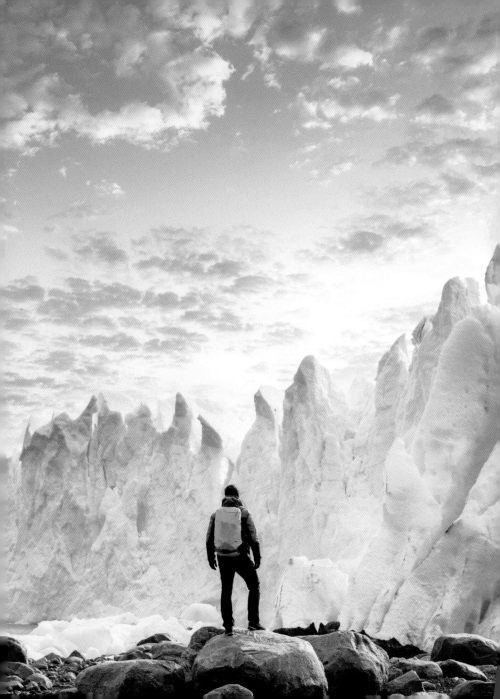

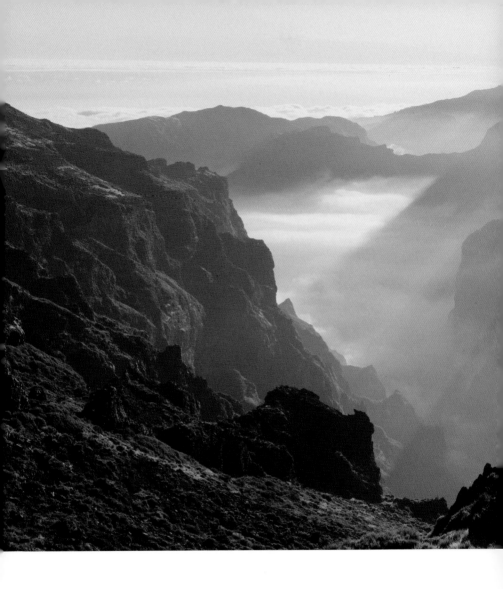

Pico do Arieiro, Madeira, Portugal
32.7356° N, 16.9289° W

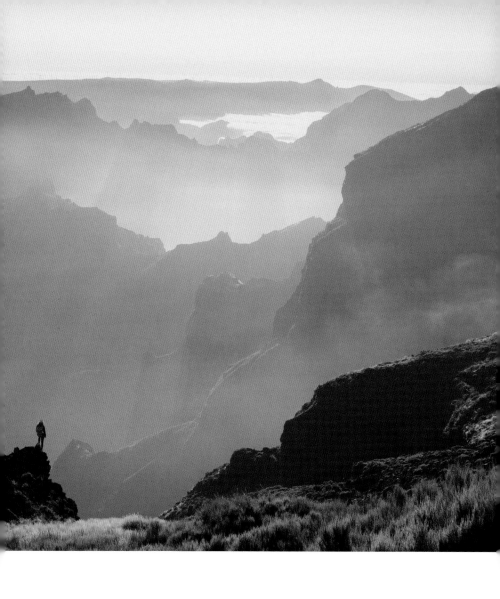

Madakaripura Waterfall, East Java, Indonesia
7.8541° S, 113.0082° E

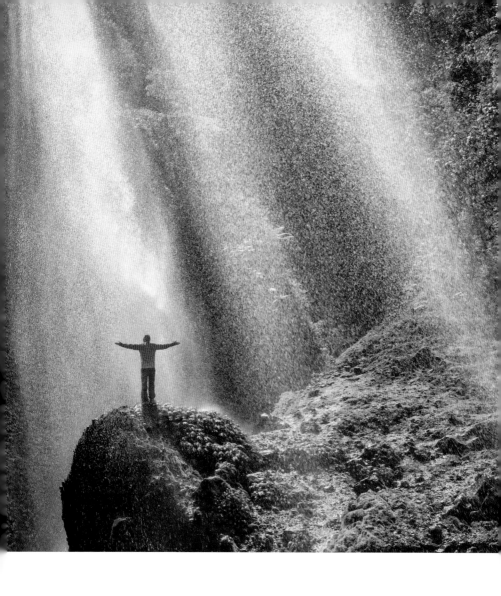

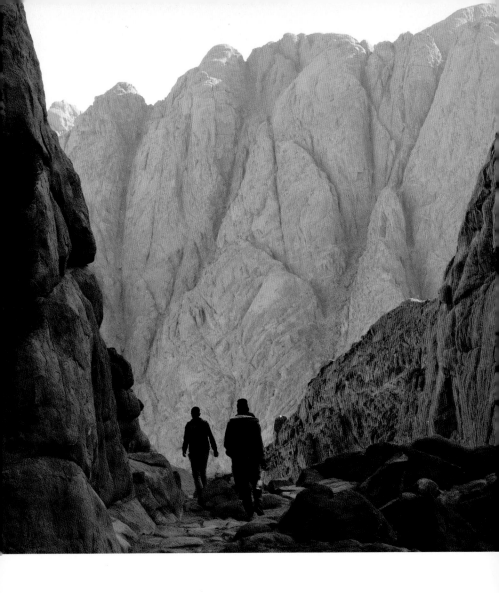

Steps of Penitence, Sinai, Egypt
28.5390° N, 33.9753° E

'Some humans
say trees are not
sentient beings,

But they do not
understand poetry–'

–Joy Harjo

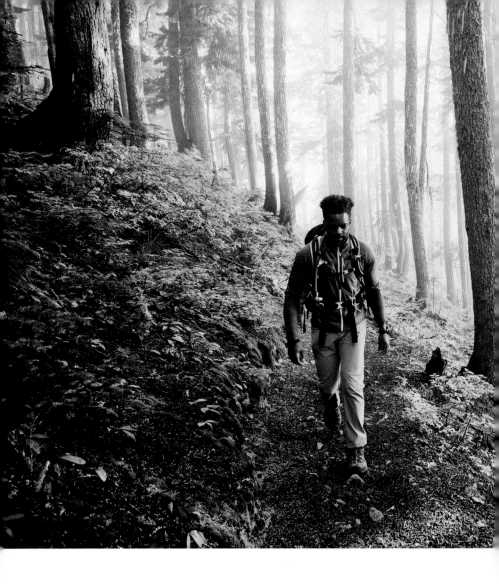

Snoqualmie Pass, Washington, USA
47.3923° N, 121.4001° W

@BARWICK_PHOTO

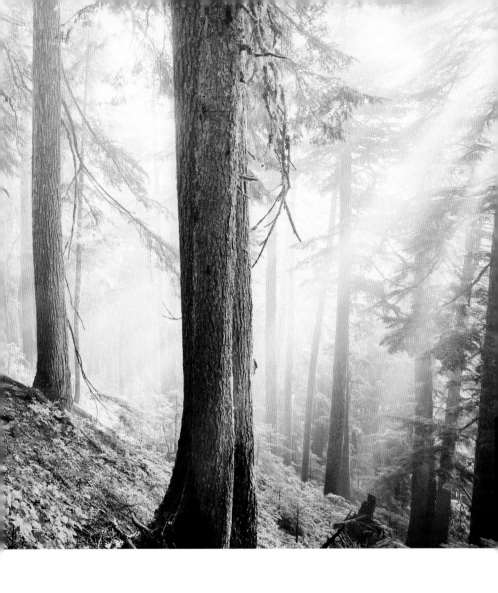

Appalachian Trail, Tennessee, USA
35.7838° N, 83.1138° W

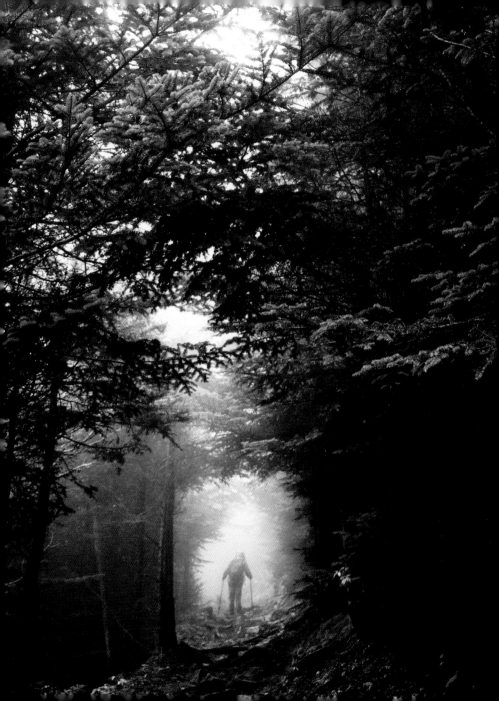

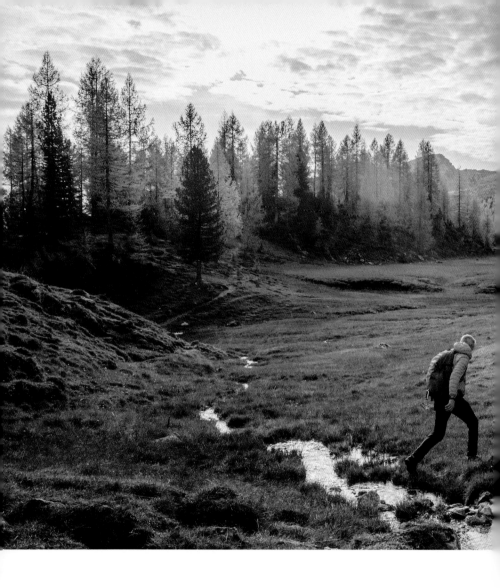

Cortina d'Ampezzo, Belluno, Italy
46.5405° N, 12.1357° E

@MASSIMOCOLOMBO2.0

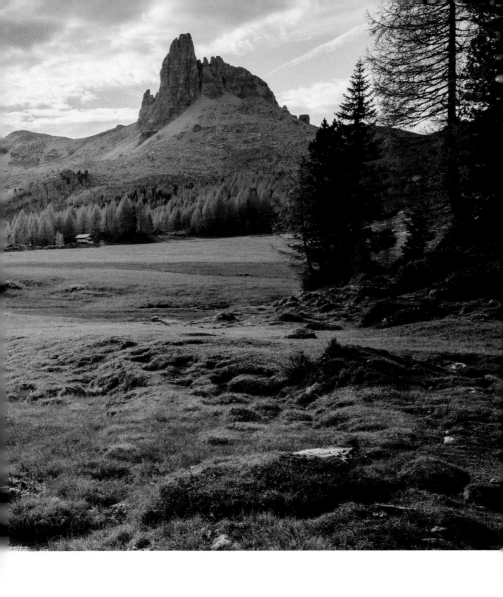

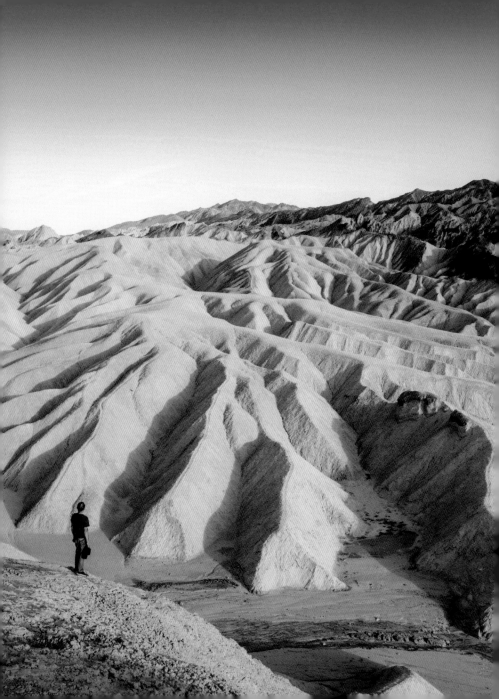

Death Valley, California, USA
36.5054° N, 117.0794° W

@MATTEOCOLOMBOPHOTOGRAPHY

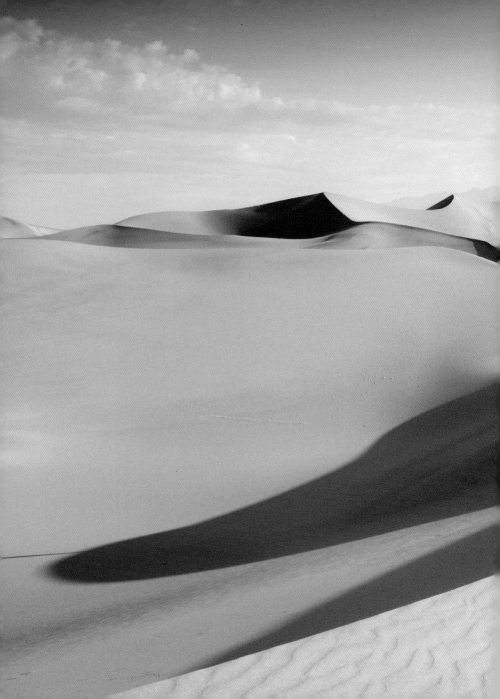

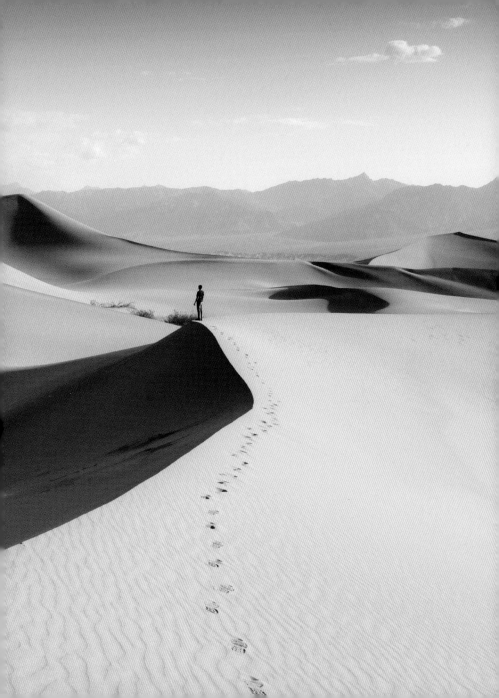

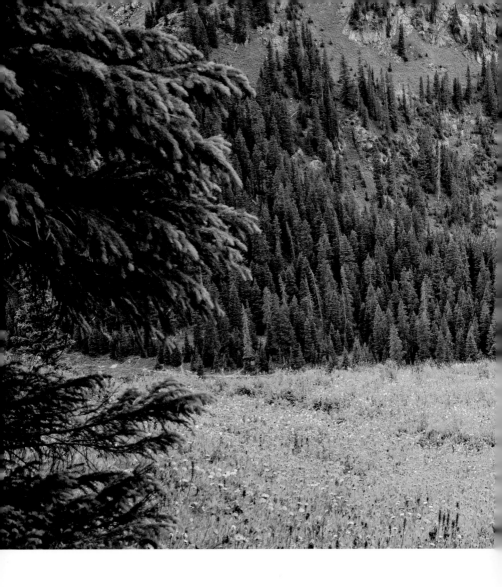

Mount Sneffels Wilderness, Colorado, USA
38.0100° N, 107.8778° W

@ADVENTURE_PHOTO

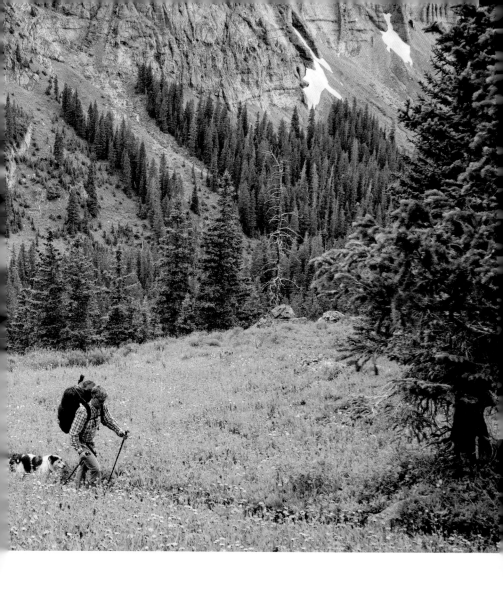

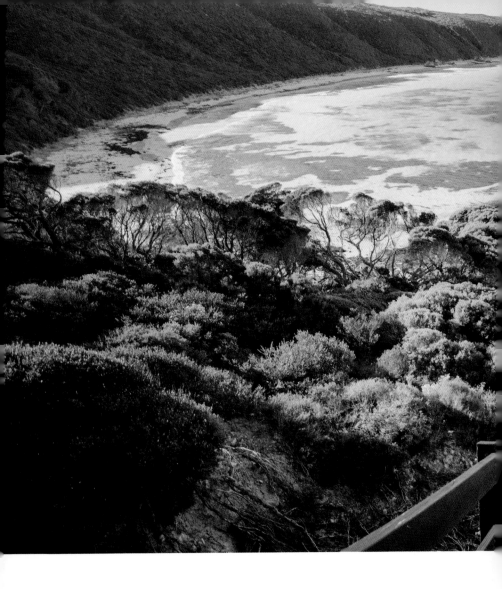

Esperance, Western Australia, Australia
33.8613° S, 121.8914° E

@JCRUXPHOTO

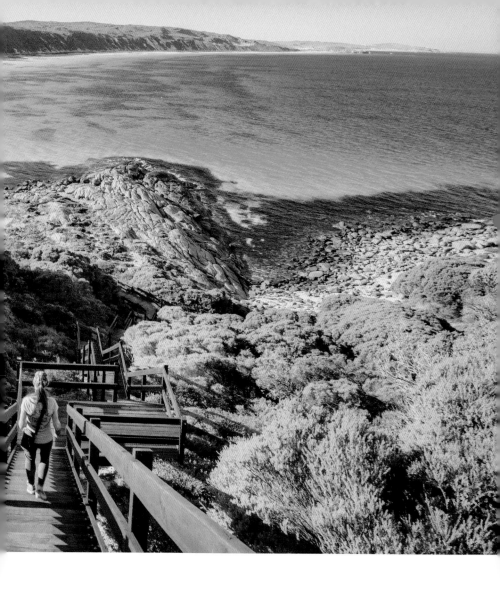

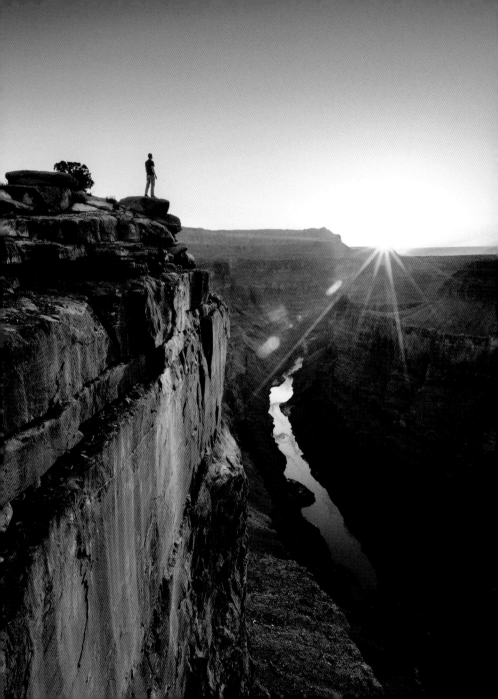

Toroweap Overlook, Arizona, USA
6.2144° N, 113.0565° W

@MATTEOCOLOMBOPHOTOGRAPHY

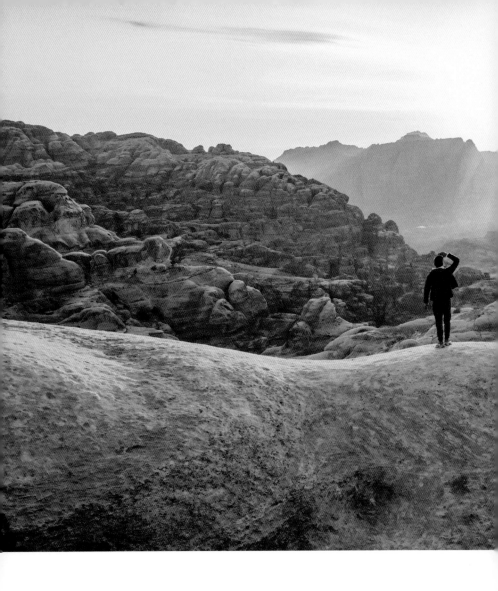

Petra, Ma'an, Jordan
30.3216° N, 35.4801° E

@ARTURDEBAT

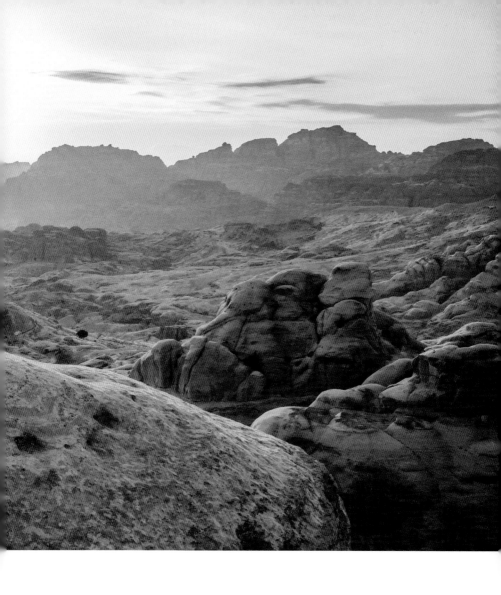

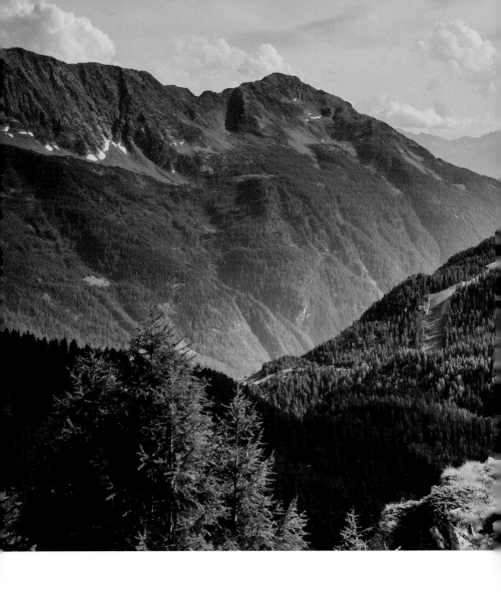

Valmalenco, Lombardy, Italy
46.3061° N, 9.8215° E

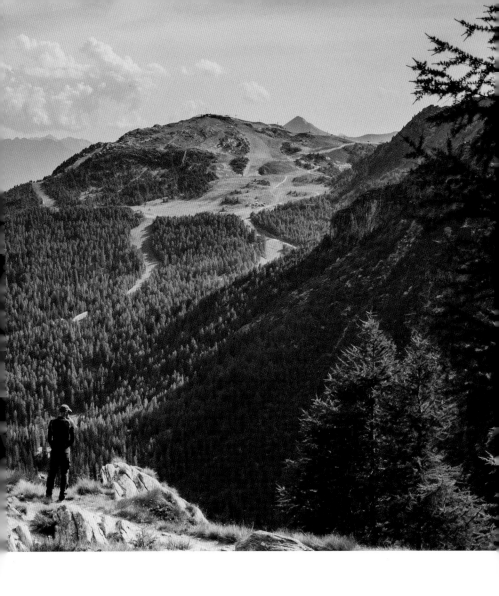

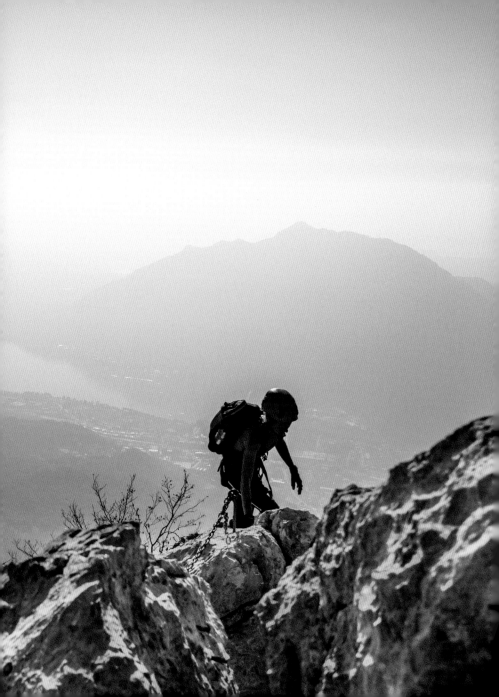

Monte San Martino, Lombardy, Italy
43.0315° N, 13.4396° E

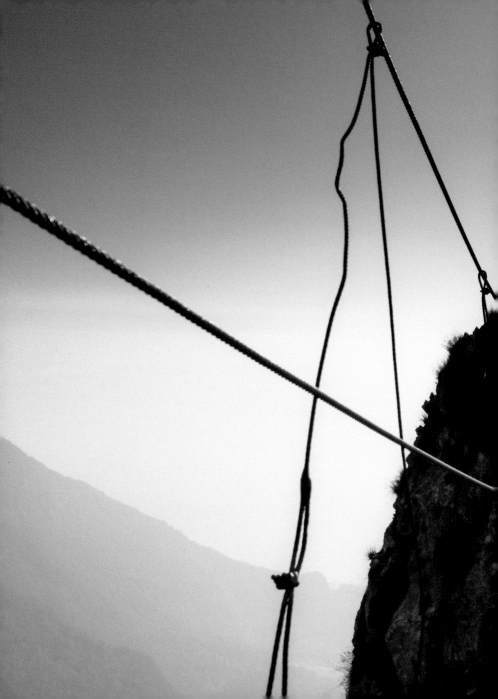

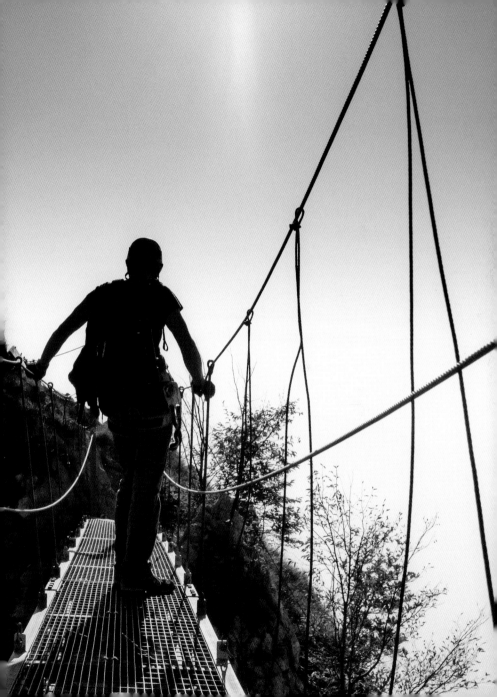

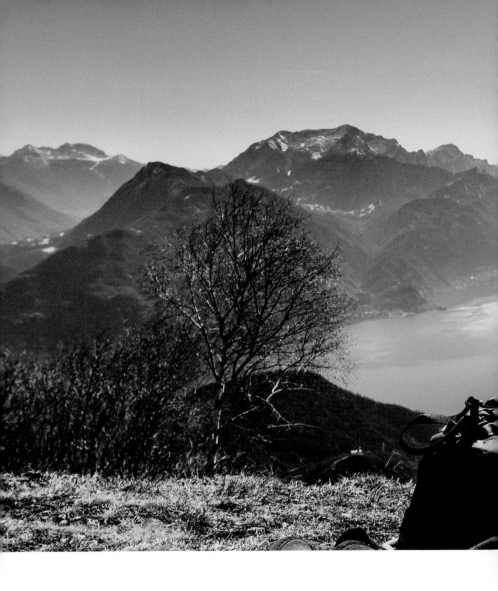

Lake Como, Lombardy, Italy
46.0160° N, 9.2572° E

@DEIMAGINE2.0

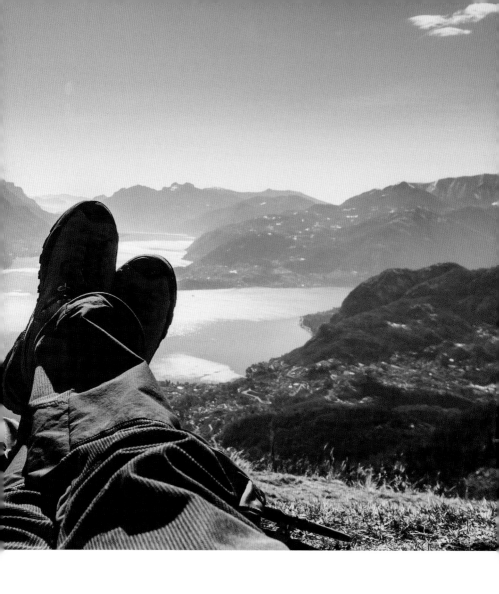

Lake Garibaldi, British Columbia, Canada
49.9366° N, 123.0272° W

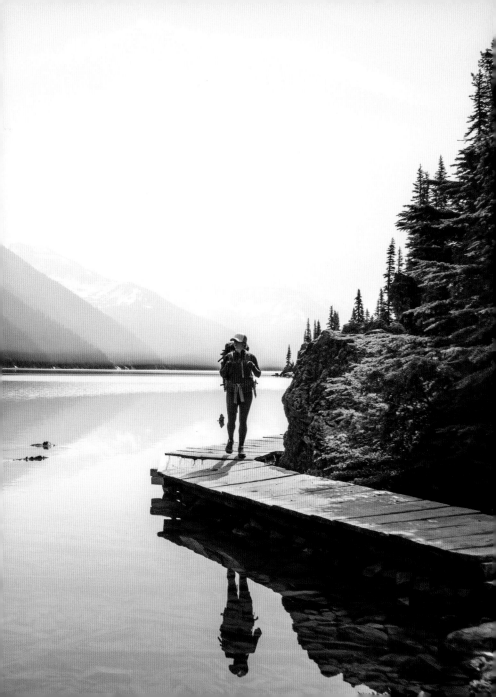

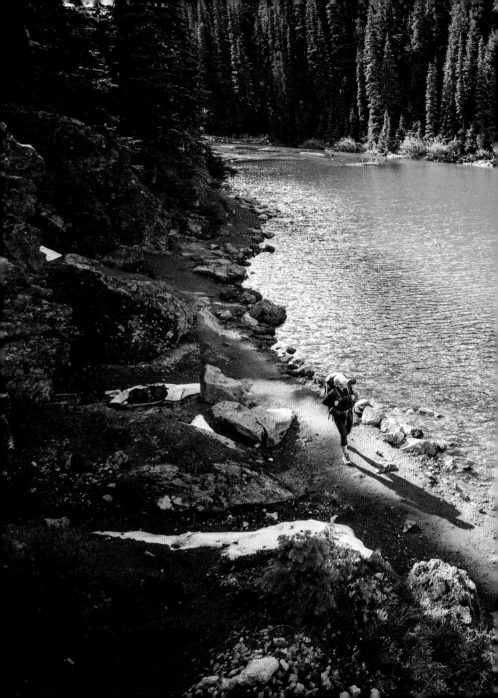

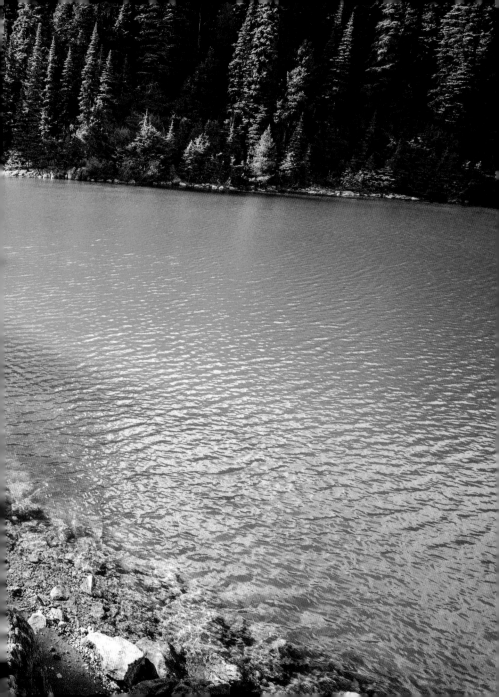

'All my early lessons have in them the breath of the woods—the fine, resinous odor of pine needles, blended with the perfume of wild grapes.'

–Helen Keller

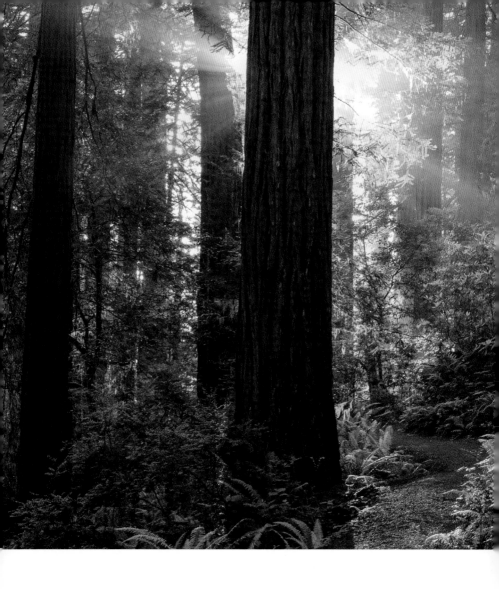

Redwood National and State Parks, California, USA
41.2132° N, 124.0046° W

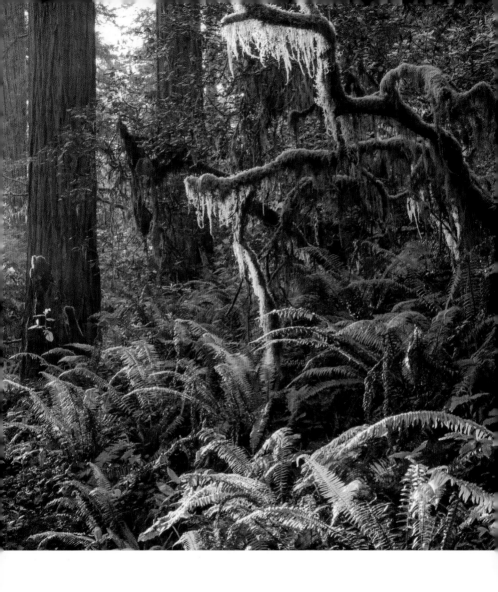

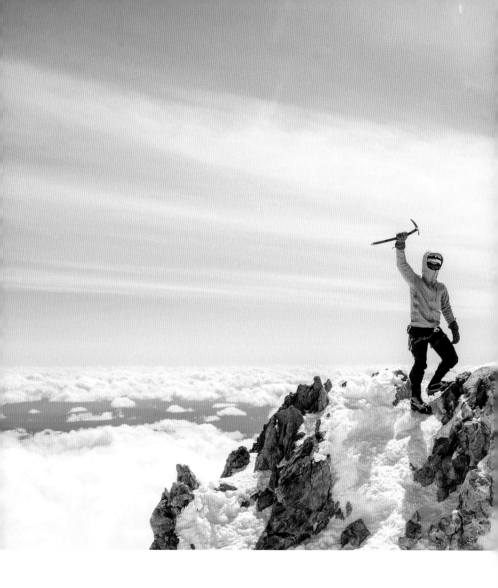

Mount Shasta, California, USA
41.3099° N, 122.3106° W

@BDOSCHER

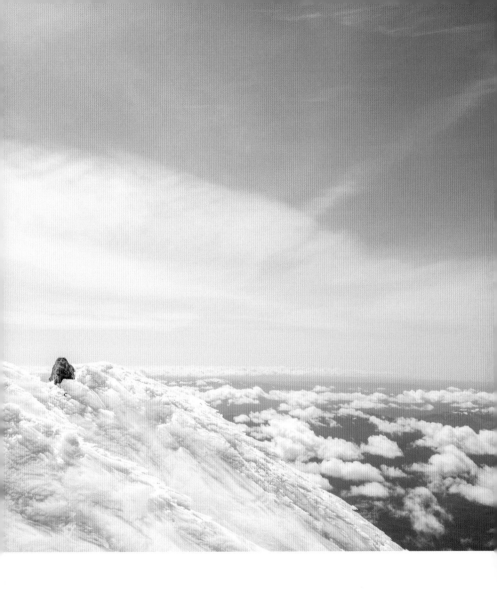

Iztaccíhuatl, Puebla, Mexico
19.1783° N, 98.6427° W

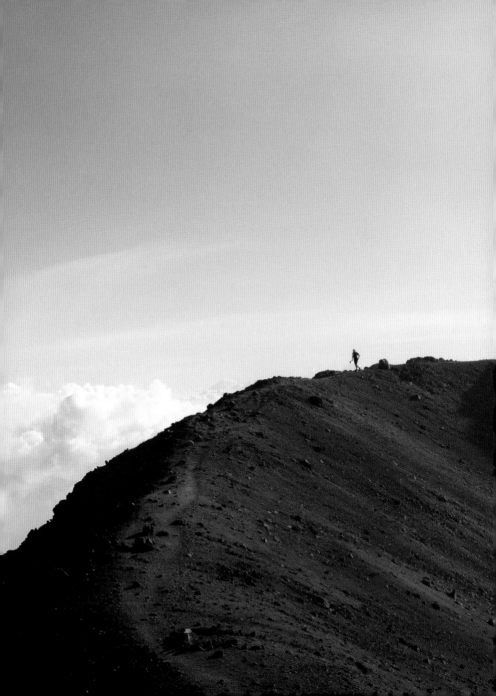

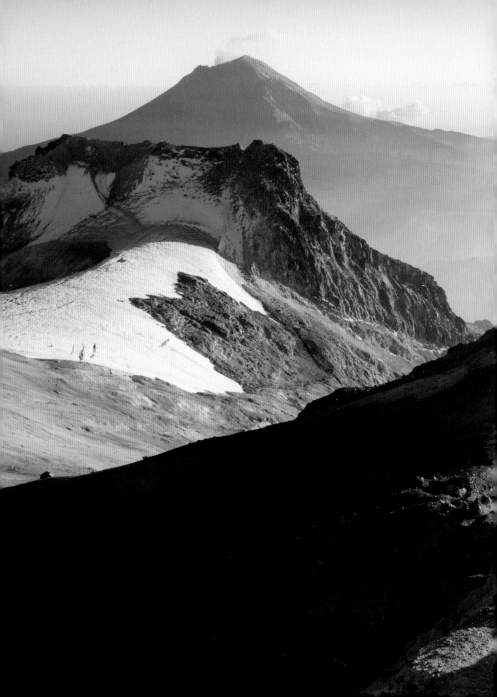

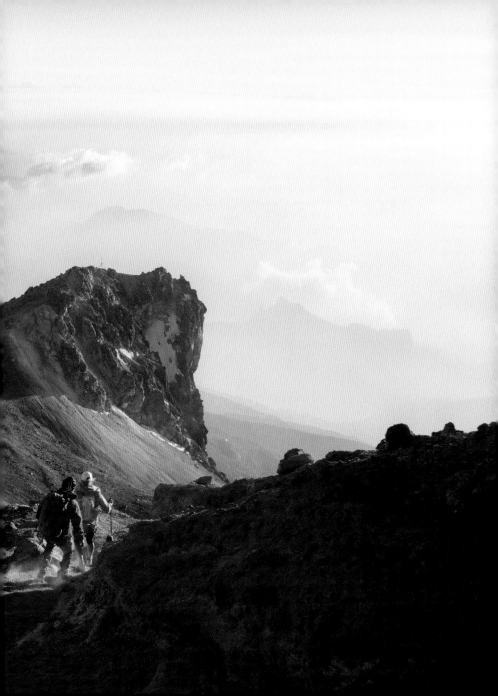

Road 1096, Chiang Mai, Thailand
18.7883° N, 98.9853° E

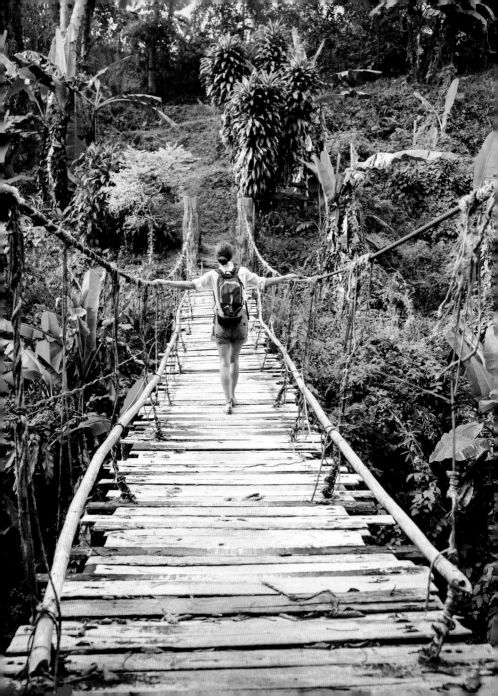

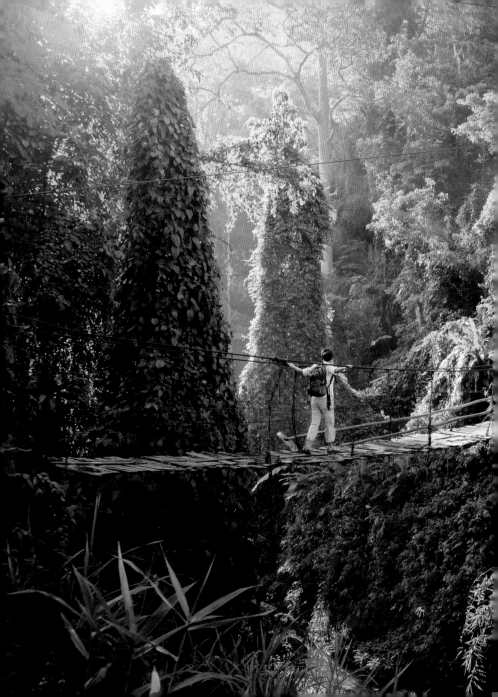

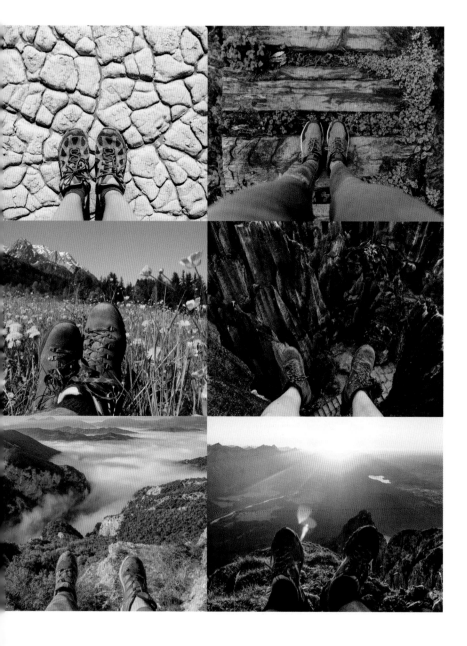

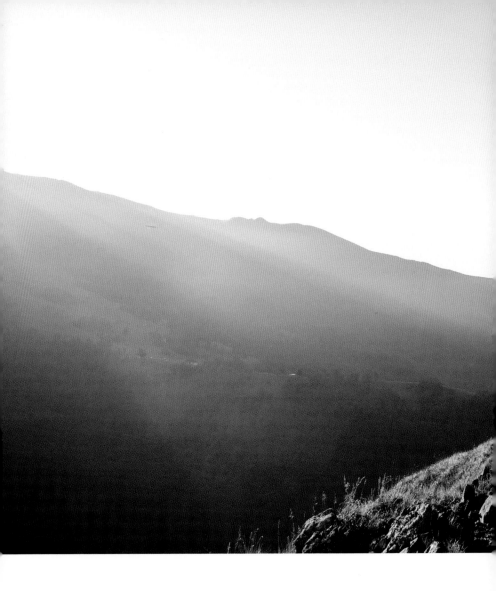

Kopaonik, Serbia
43.2680° N, 20.8263° E

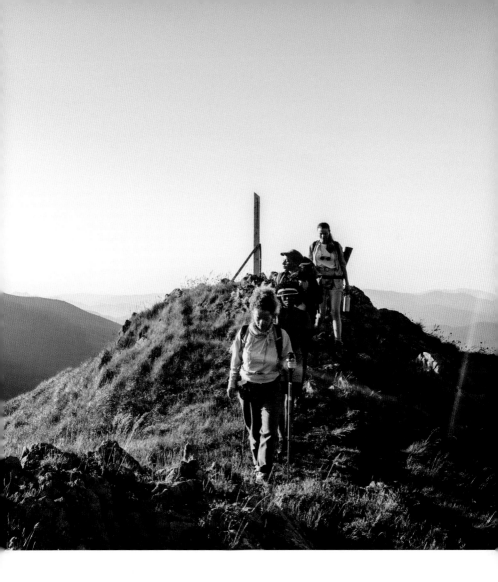

Drakensberg, Great Escarpment, Lesotho
29.4667° S, 29.2667° E

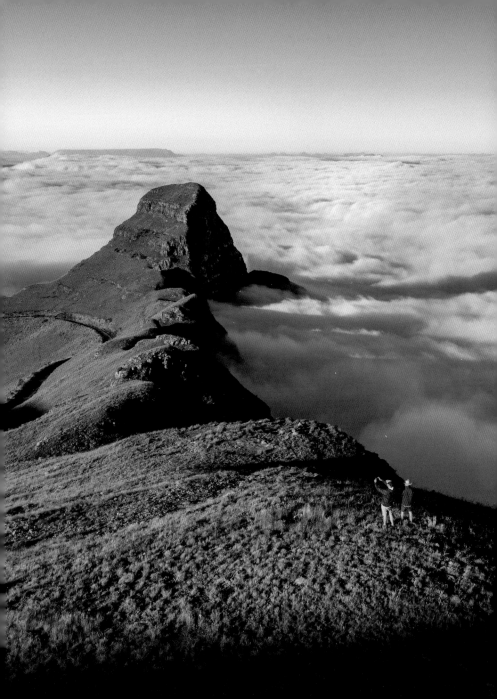

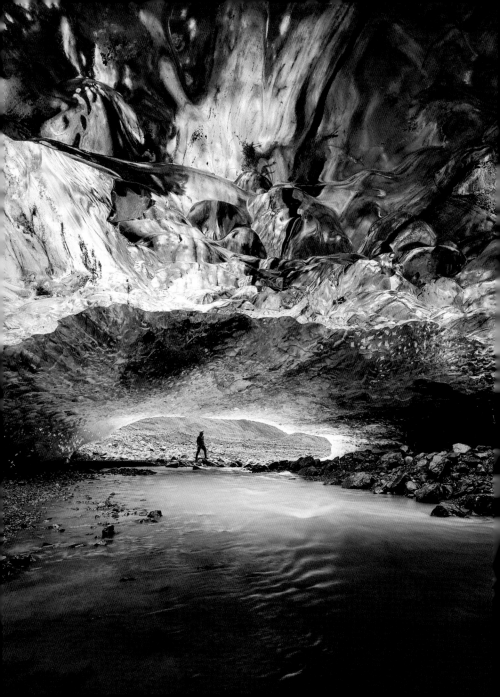

Vatnajökull, Öræfasveit, Iceland
64.7843° N, 17.2091° W

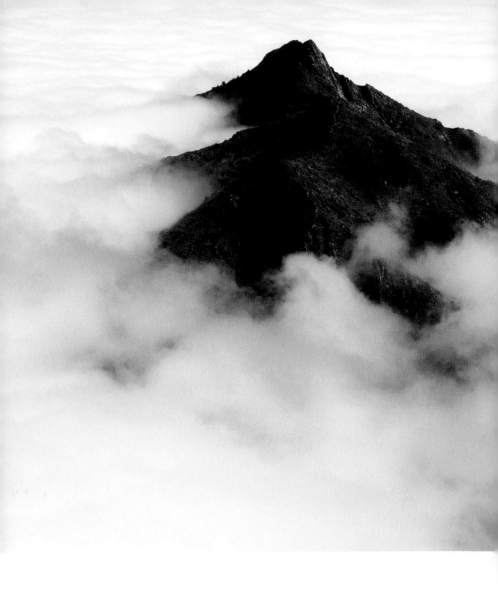

La Campana National Park, Valparaíso, Chile
32.9544° S, 71.0773° W

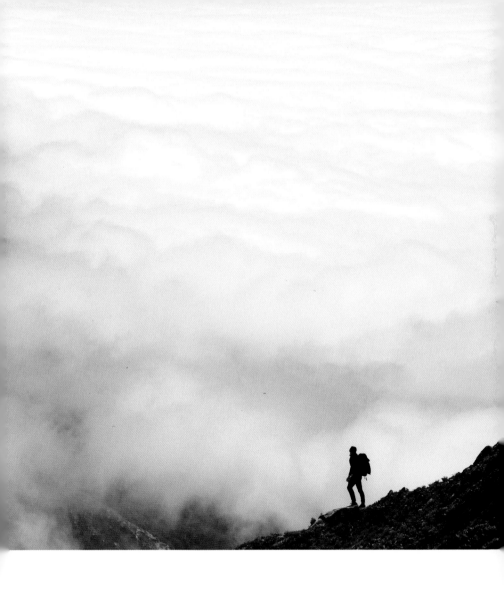

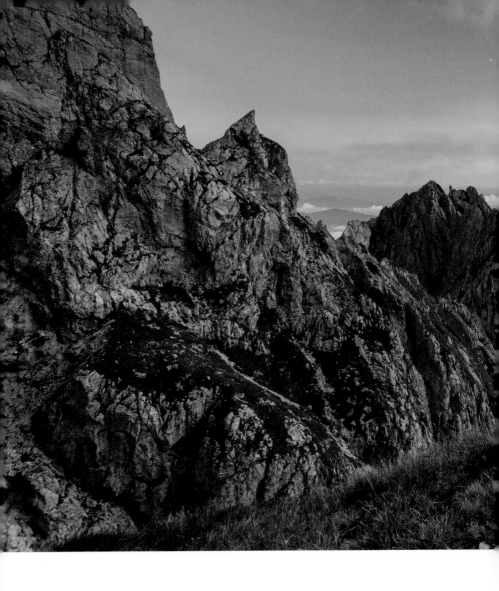

Mangart Pass, Julian Alps, Slovenia
46.4439° N, 13.6421° E

@YUMARCIN

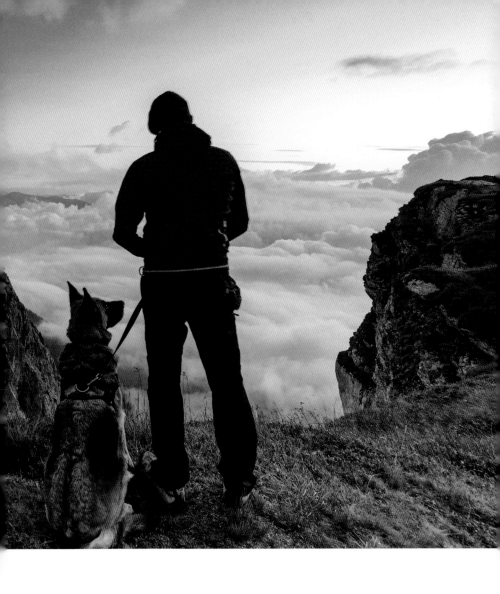

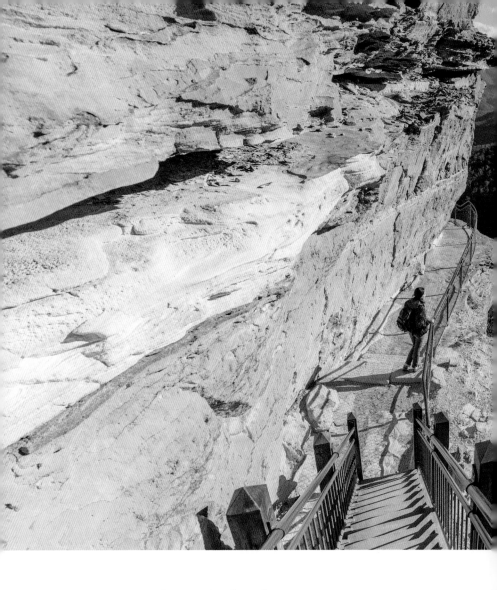

Blue Mountains, New South Wales, Australia
33.6176° S, 150.4559° E

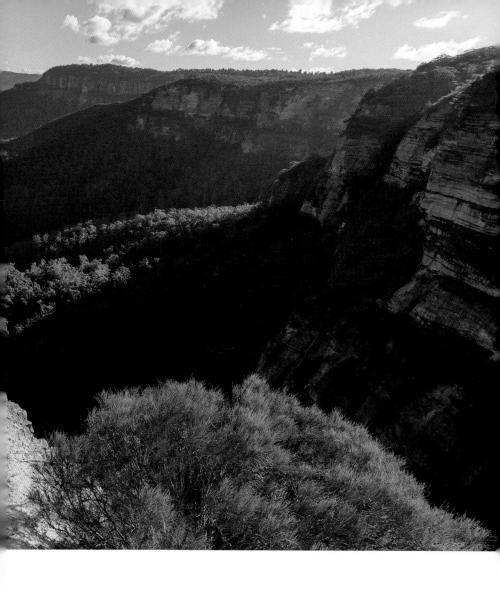

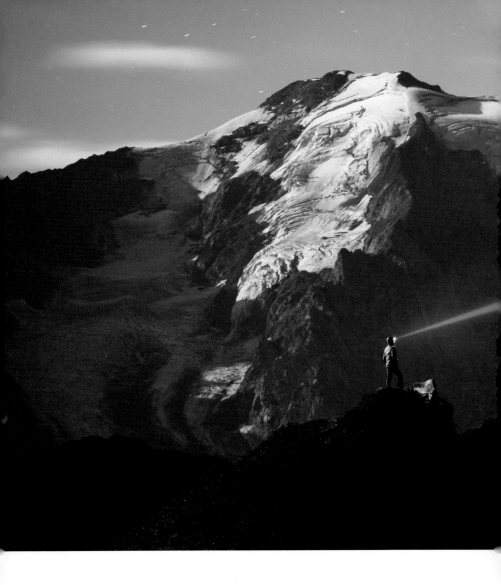

Caucasus Mountains, Samegrelo-Zemo Svaneti, Georgia
42.7352° N, 42.1689° E

@KOTENKOFOTO

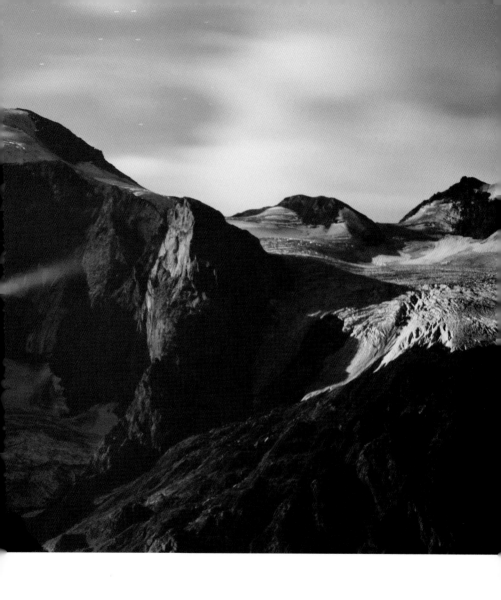

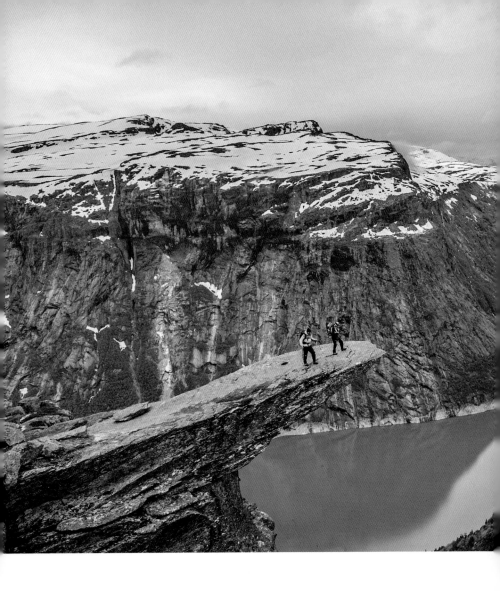

Trolltunga, Vestland, Norway
60.1242° N, 6.7400° E

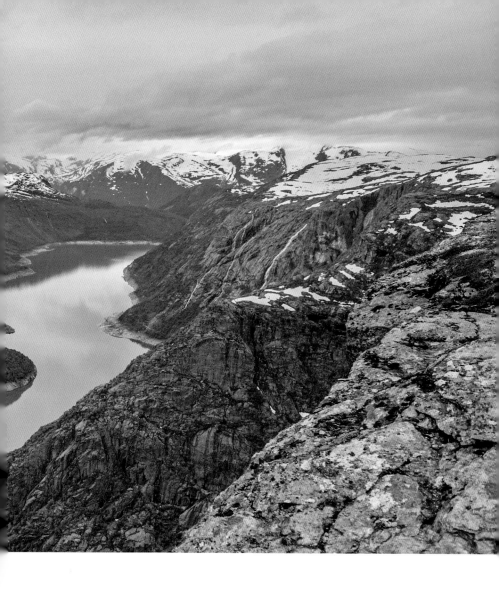

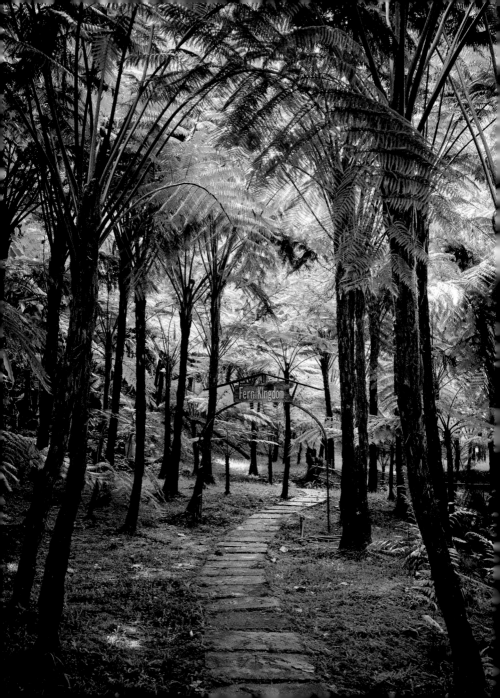

Doi Inthanon, Chiang Mai, Thailand
18.5356° N, 98.5221° E

'Resolve and even courage are needed to get through the tough times: rain, snow, scorching sun, insects, unfavourable terrain. The rewards are the good times: beautiful scenery, outdoor life, increased feeling of self-worth, new friends.'

–Christoper Whalen

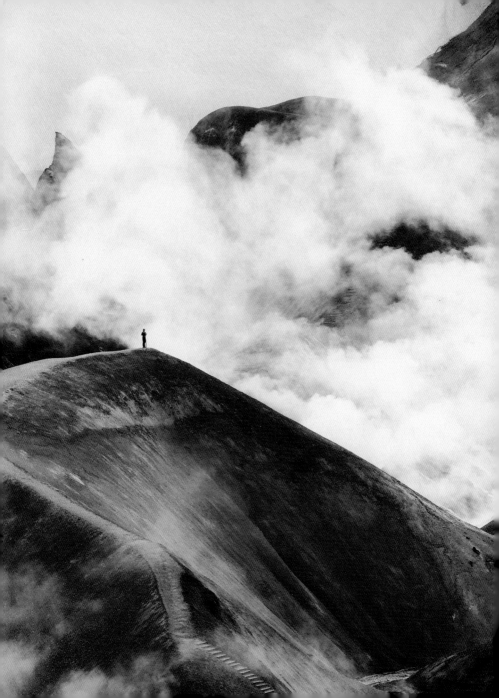

Kerlingarfjöll, Icelandic Highlands, Iceland
64.6366° N, 19.2694° W

@SANNALINN

The Chasm Walk, Fiordland, New Zealand
44.7214° S, 167.9501° E

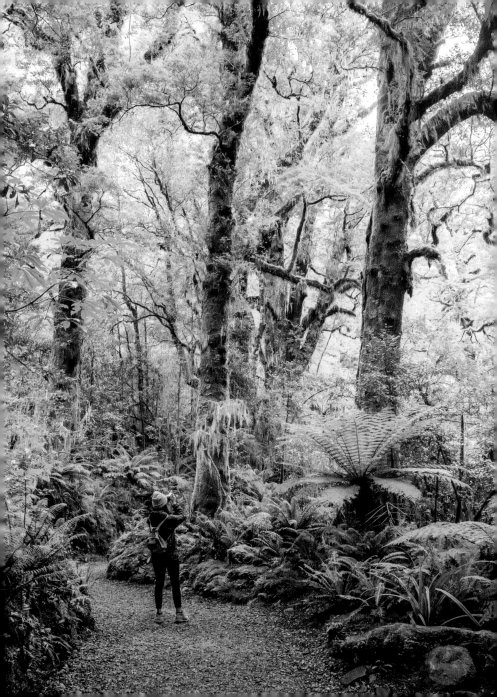

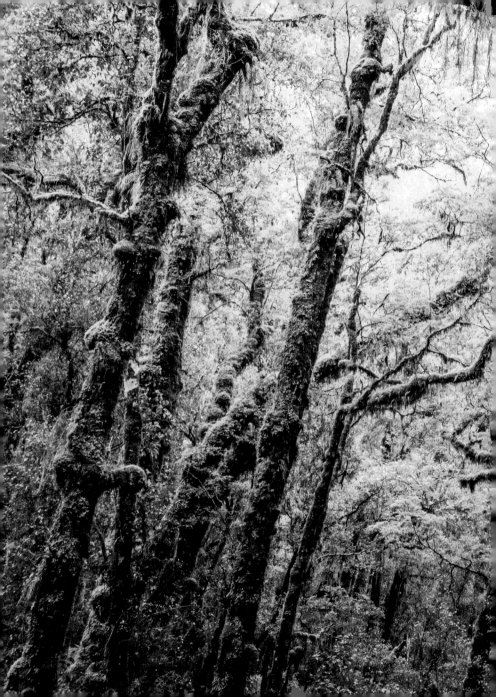

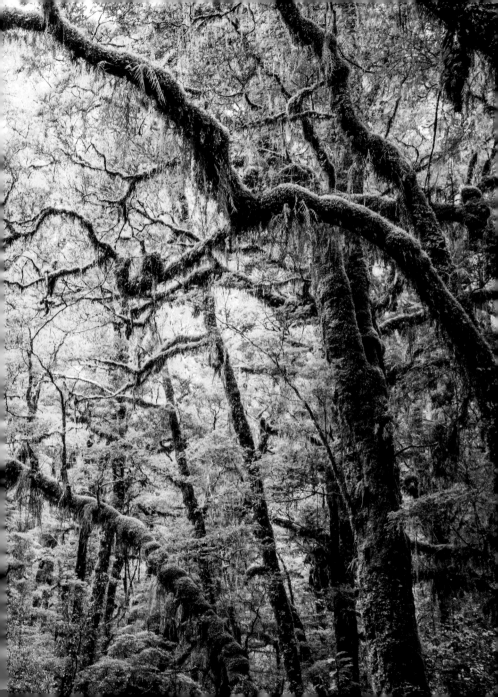

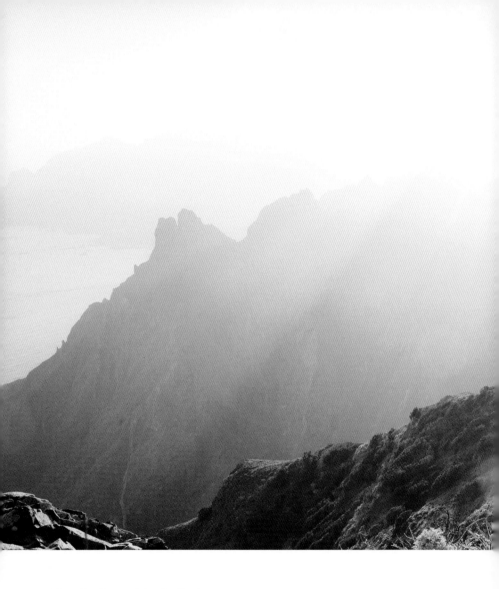

Tenerife, Canary Islands, Spain
28.2916° N, 16.6291° W

@ANDRII_LUTSYK

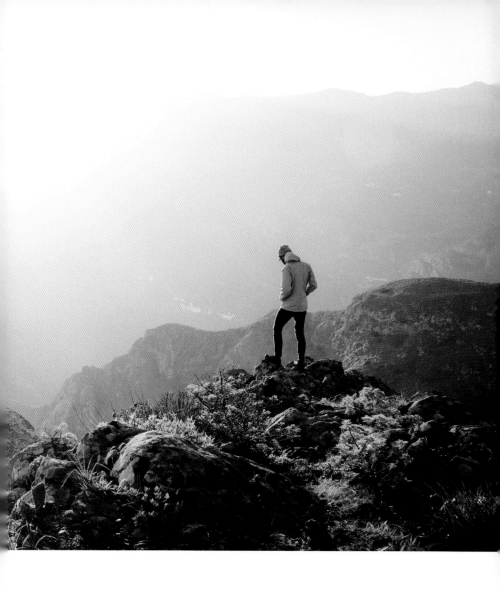

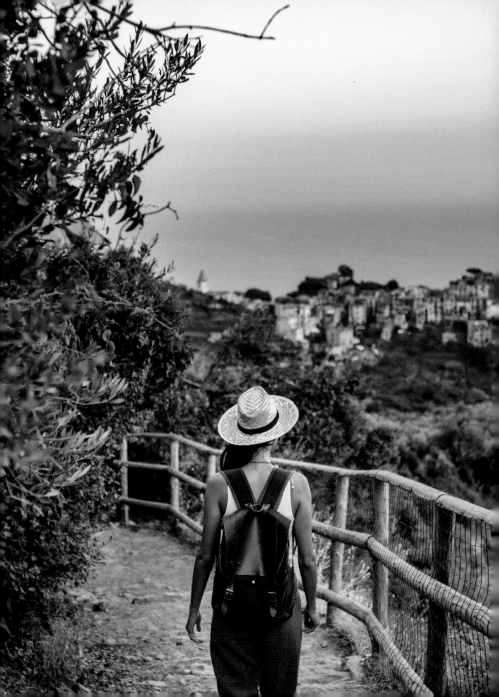

Cinque Terre, Liguria, Italy
44.1461° N, 9.6439° E

@M_STUDIO_IMAGES

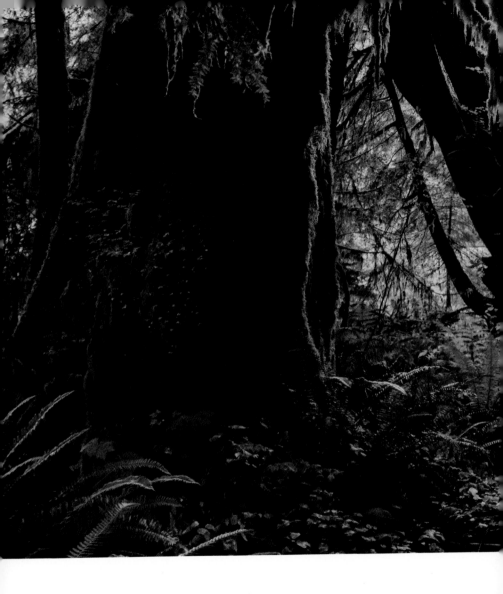

Carmanah Walbran Provincial Park, British Columbia, Canada
48.6534° N, 124.6385° W

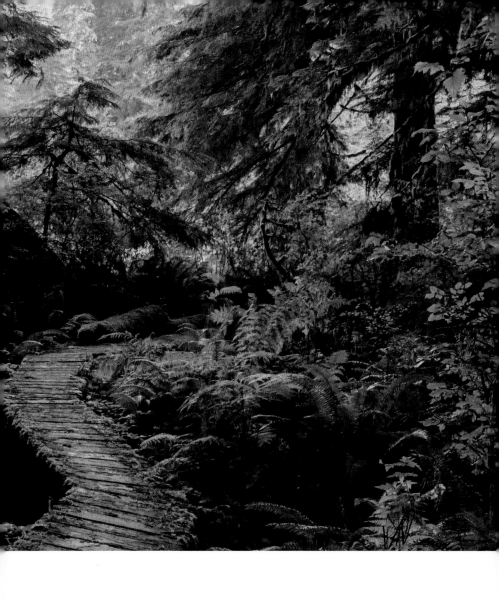

Mount Seymour Provincial Park, British Columbia, Canada
49.3974° N, 122.9248° W

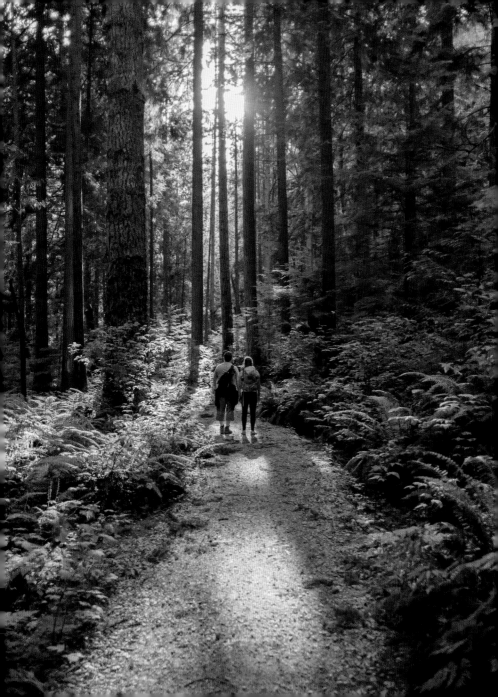

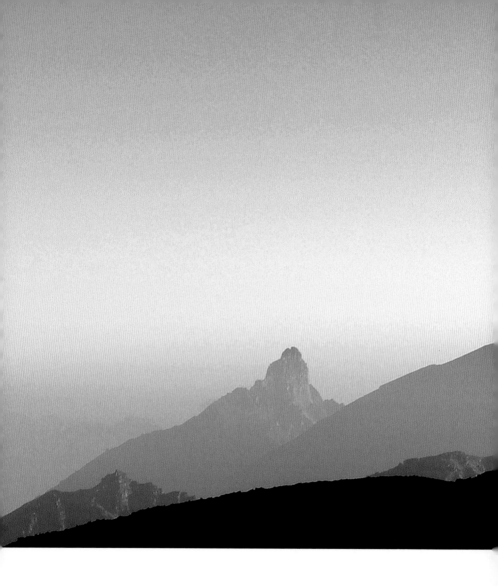

Courmayeur, Valle d'Aosta, Italy
45.7969° N, 6.9690° E

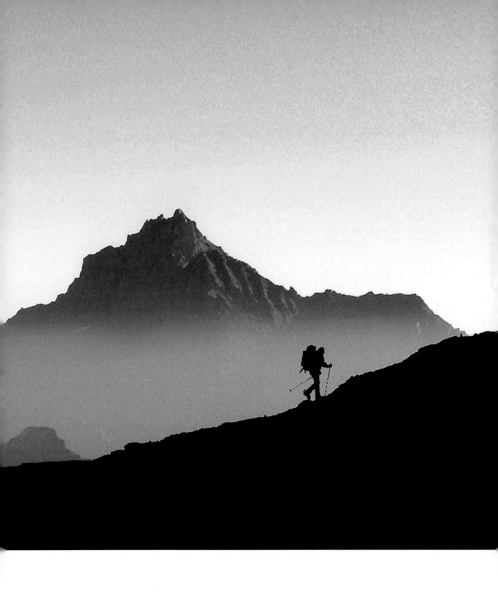

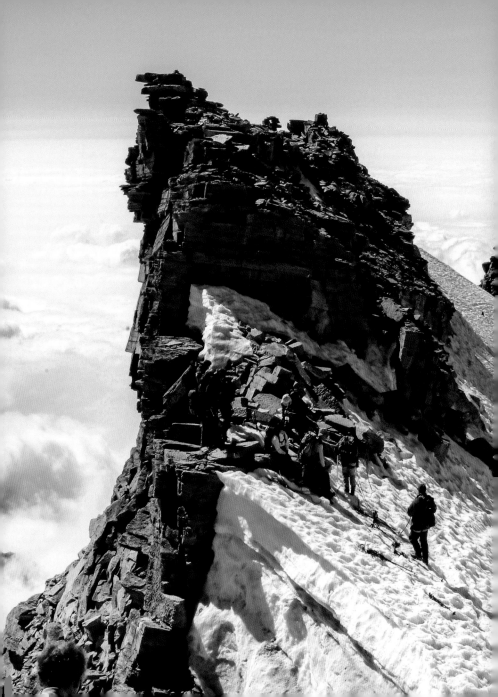

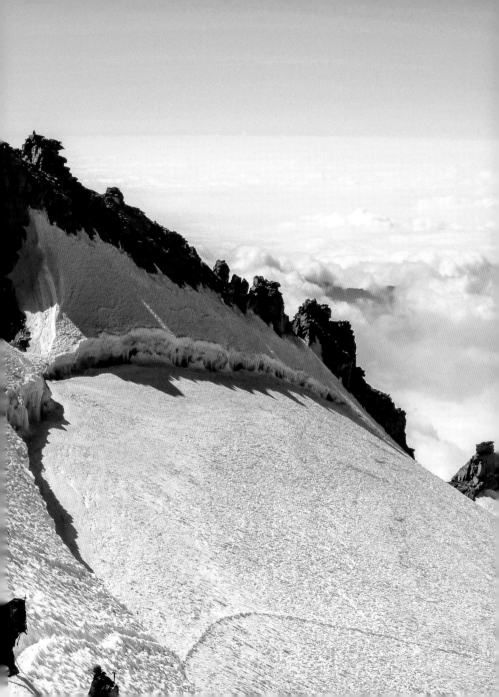

Sossusvlei, Namib-Naukluft, Namibia
23.0833° S, 15.1667° E

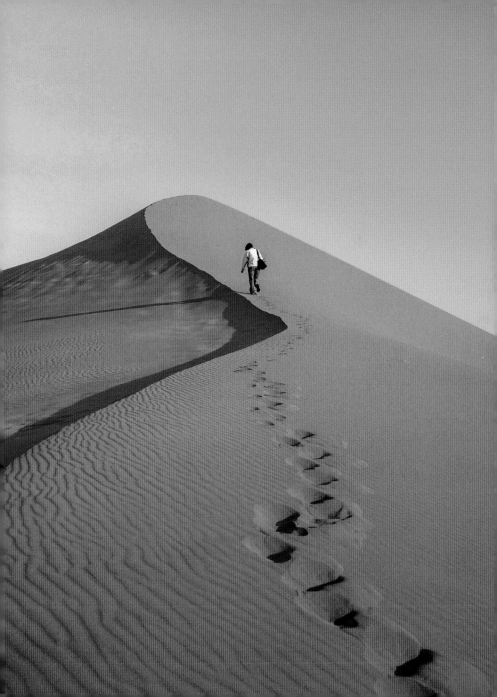

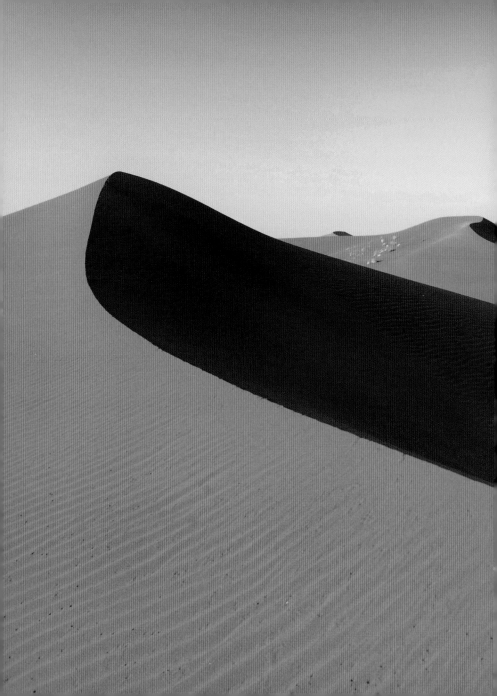

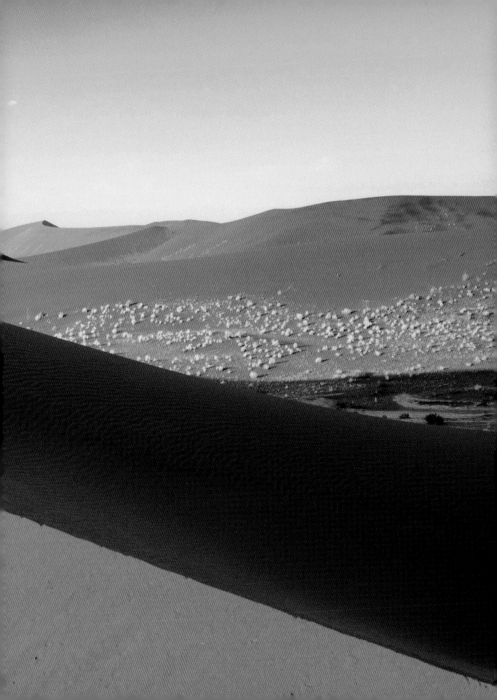

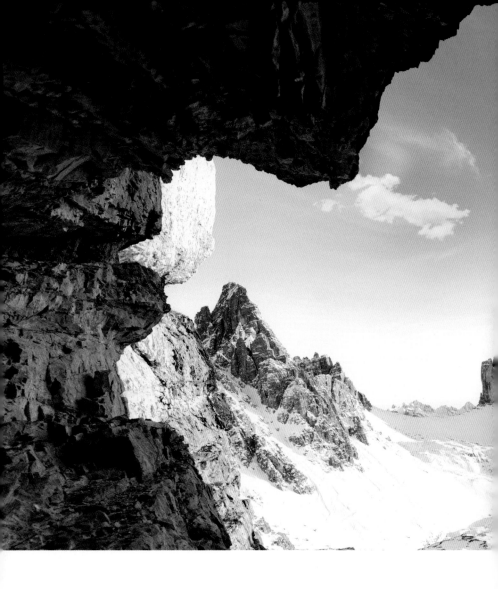

Dolomites, Trentino-South Tyrol, Italy
46.4102° N, 11.8440° E

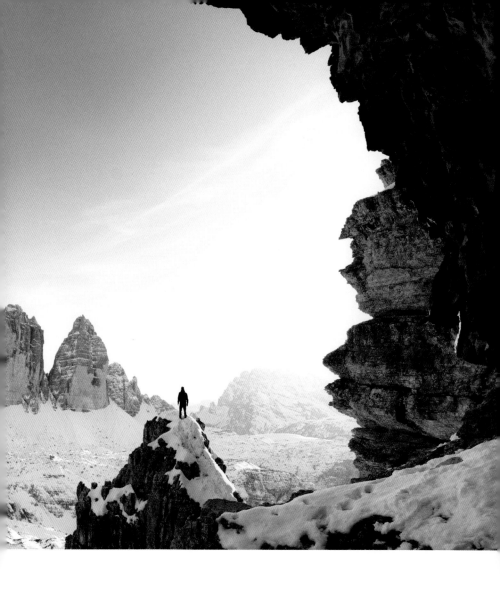

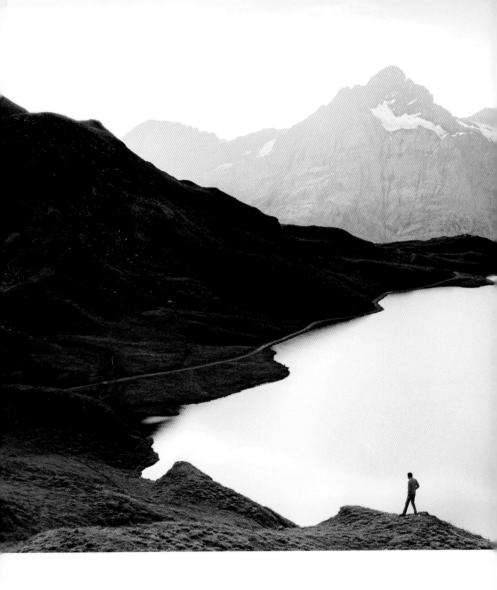

Bachalpsee, Bernese Oberland, Switzerland
46.6694° N, 8.0233° E

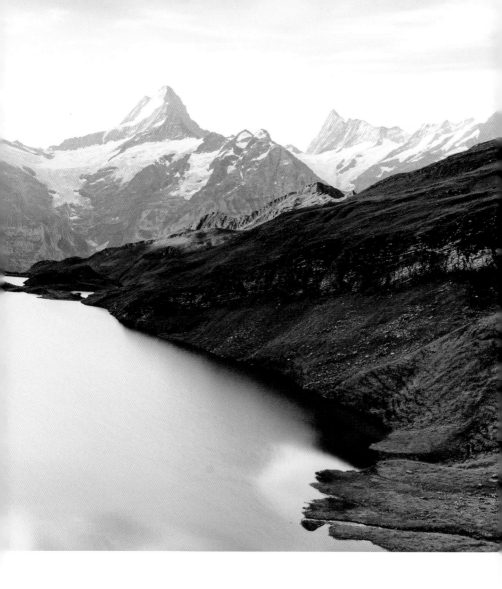

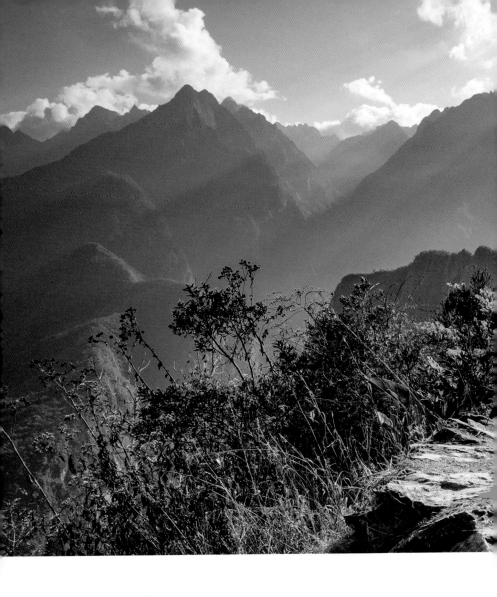

Inca Trail, Andes, Peru
13.1631° S, 72.5450° W

RYAN MORRIS

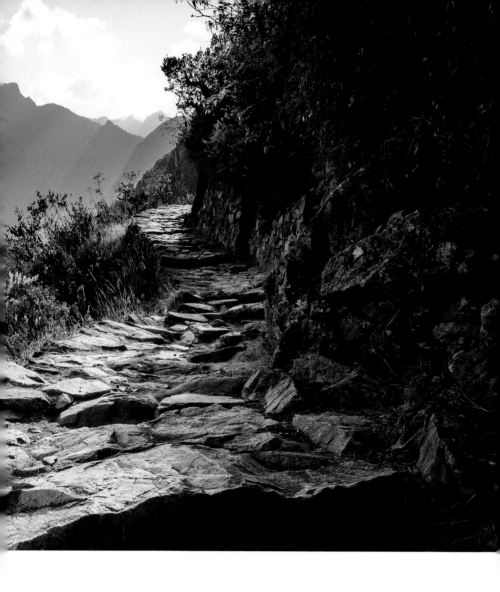

Annapurna, Himalayas, Nepal
28.5961° N, 83.8203° E

@ALEKSANDARNAKIC

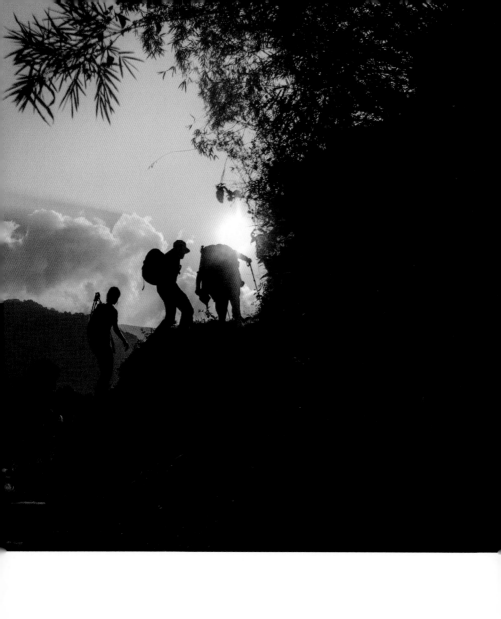

'The trail is the thing, not the end of the trail. Travel too fast, and you miss all you are traveling for.'

–Louis L'Amour

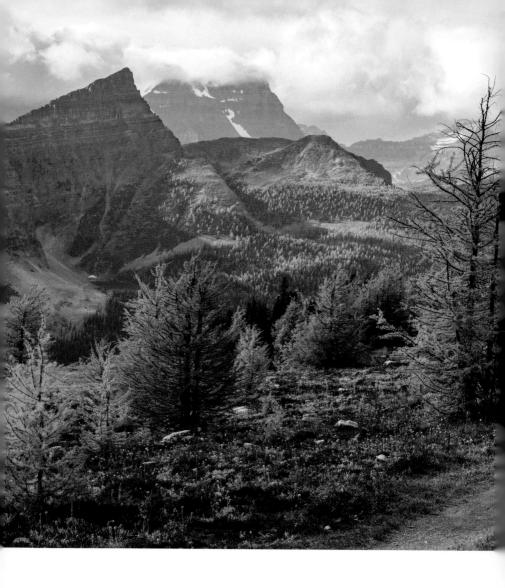

Healy Pass Trail, Banff National Park, Alberta, Canada
51.0995° N, 115.8745° W

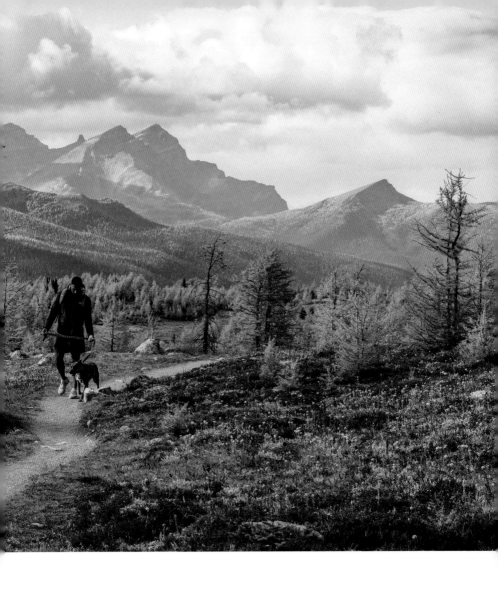

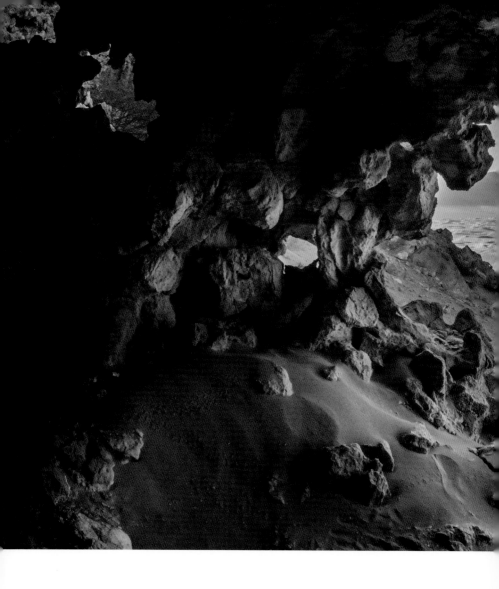

Pink Rock, Al Madam, United Arab Emirates
25.0228° N, 55.7292° E

@LALNALLATH

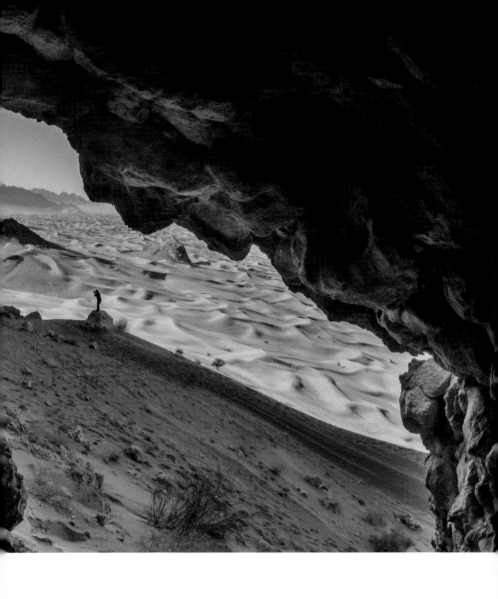

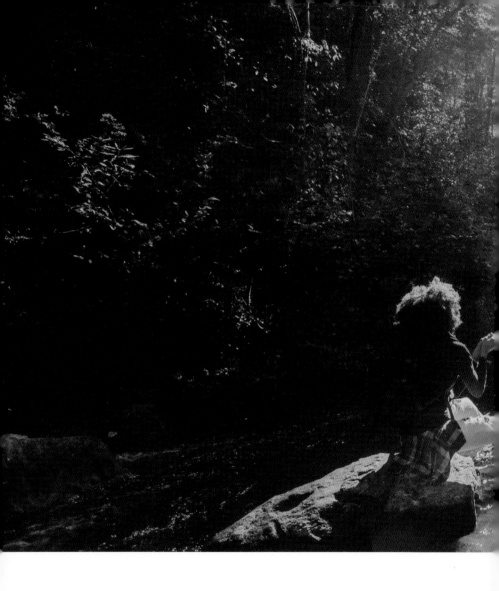

Toccoa Falls, Georgia, USA
34.5962° N, 83.3599° W

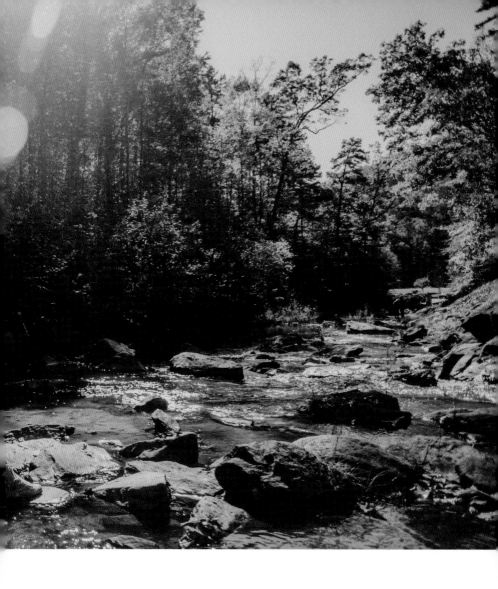

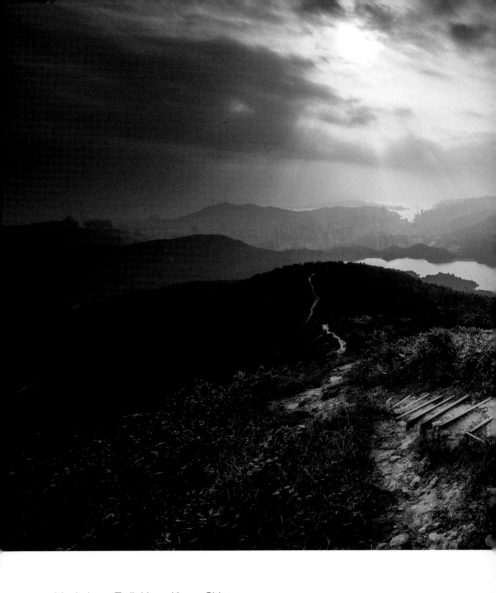

MacLehose Trail, Hong Kong, China
22.3627° N, 114.3496° E

@ARLING.HK

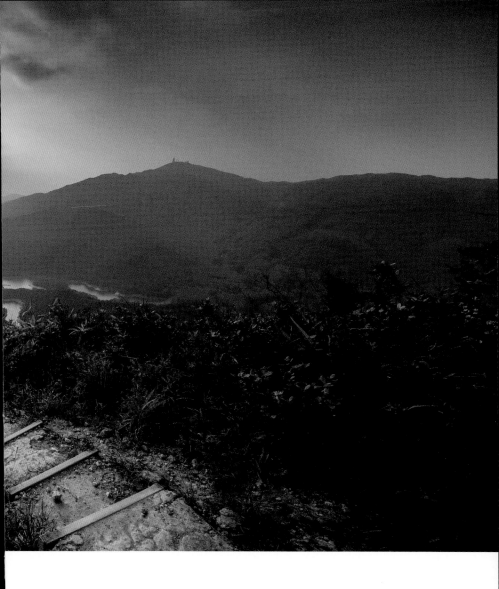

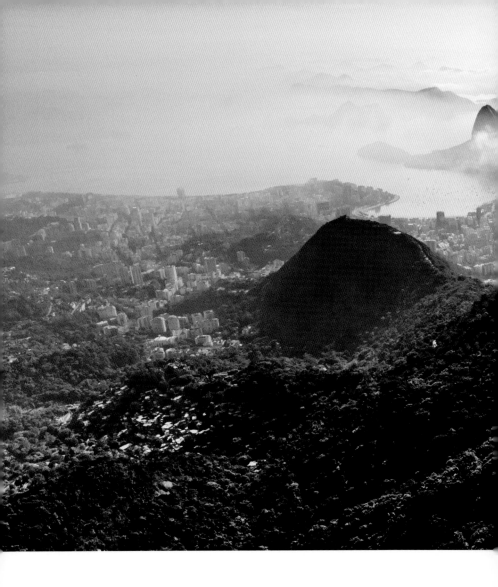

Corcovado, Rio de Janeiro, Brazil
22.9524° S, 43.2114° W

@COKADAO

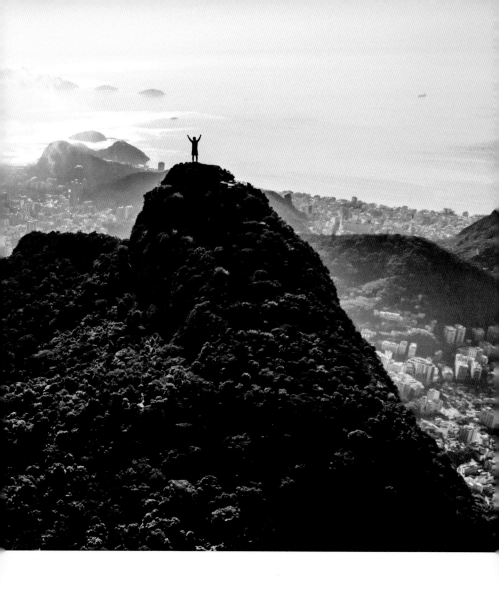

Halnaker, West Sussex, England
50.8667° N, 0.7104° W

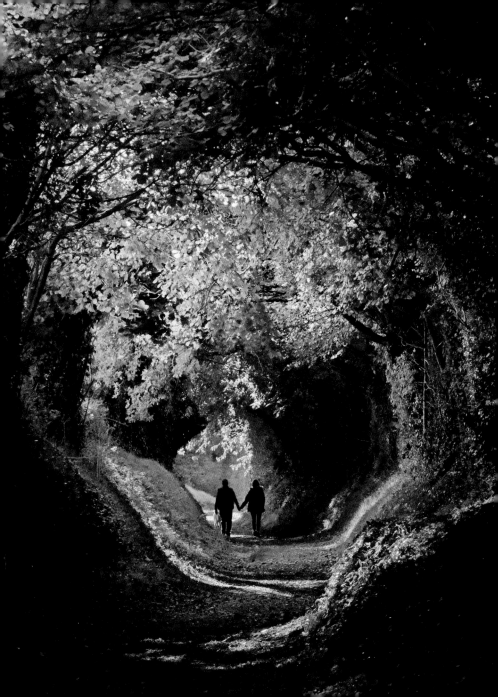

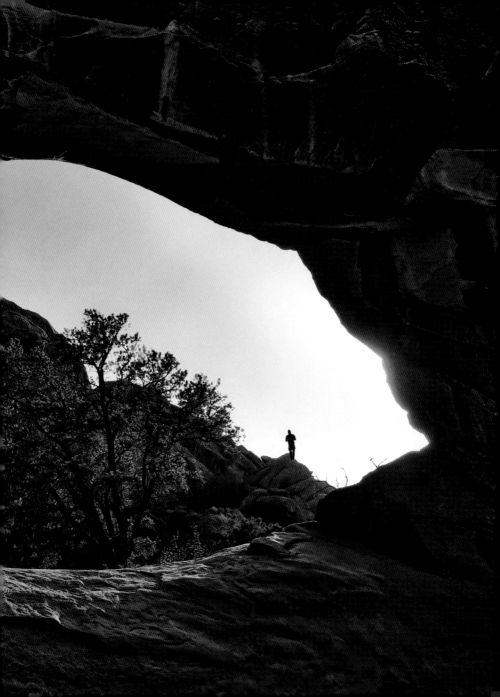

Double O Arch, Utah, USA
38.7991° N, 109.6211° W

@GEORGEPETERSDESIGN

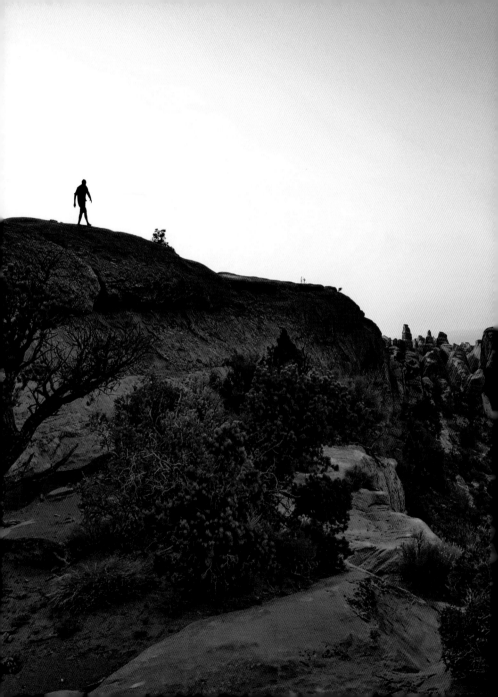

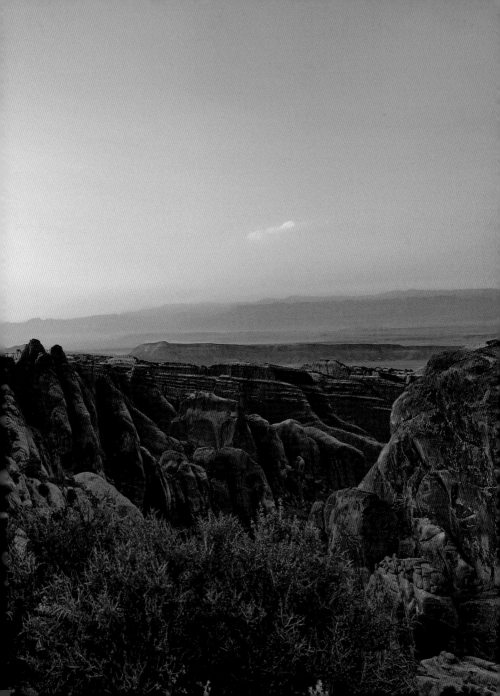

Vinicunca Mountain, Cusco, Peru
13.8705° S, 71.3300°W

DANIEL PRUDEK

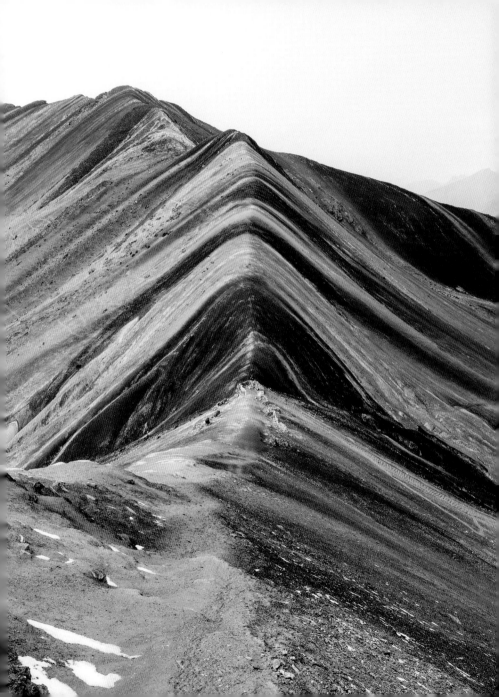

Lake Motosu, Yamanashi, Japan
35.4632° N, 138.5838° E

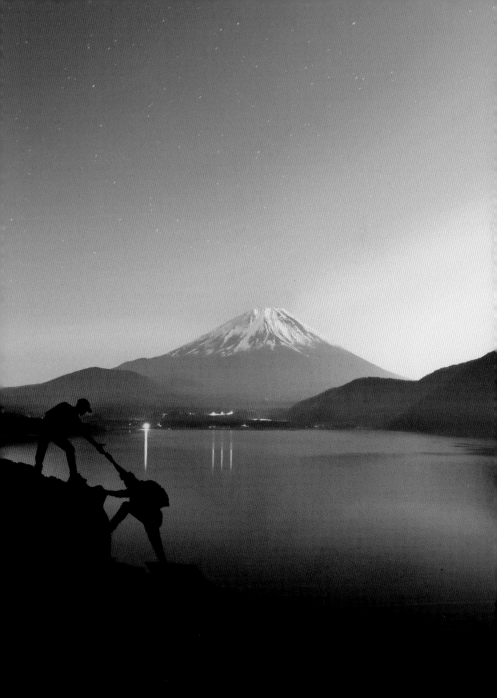

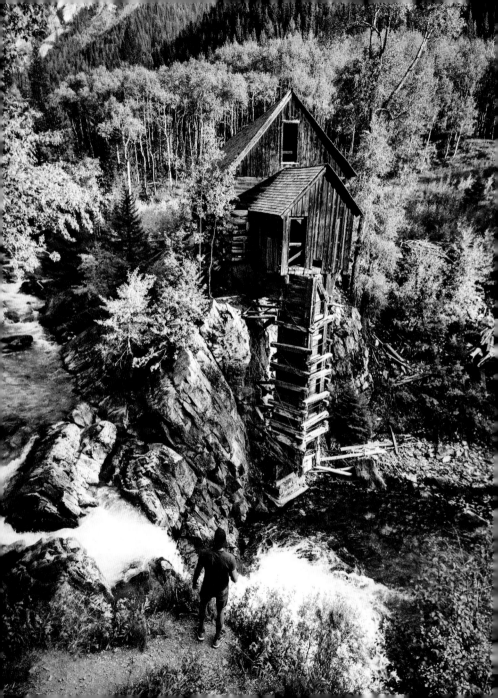

Crystal Mill, Colorado, USA
39.0590° N, 107.1045° W

@FRANCKREPORTER

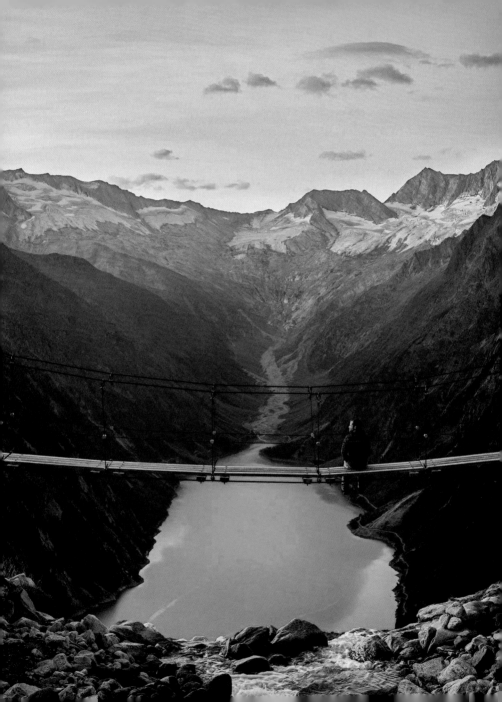

Panoramabrücke Olpererhütte, Ginzling, Austria
47.0431° N, 11.6890° E

@_MICHAEL_SCHWAN

Liegos, León, Spain
43.0244° N, 5.0758° W

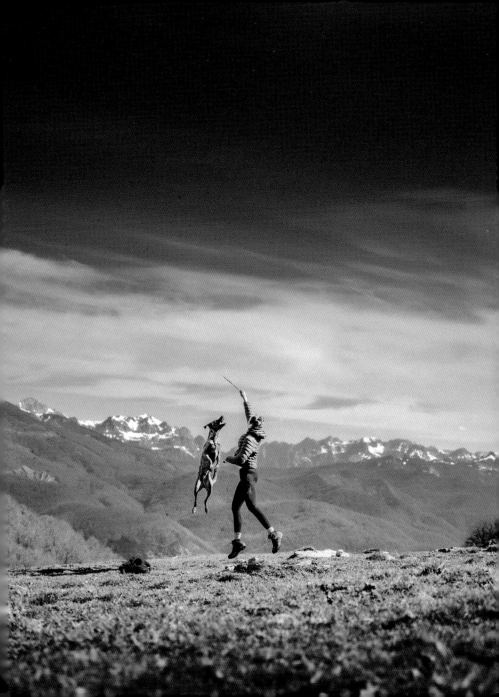

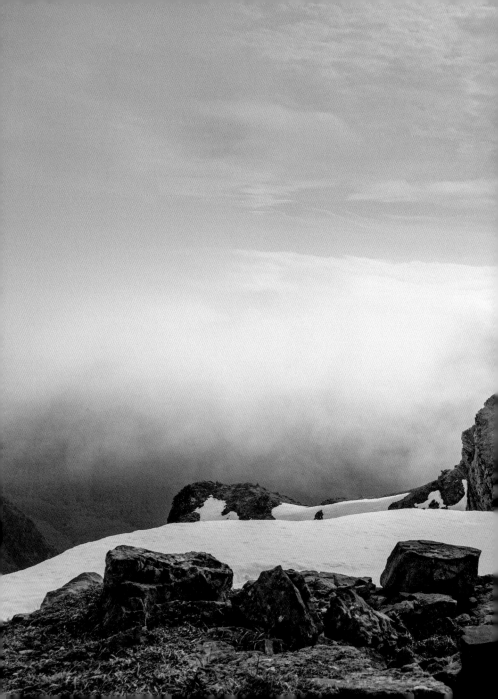

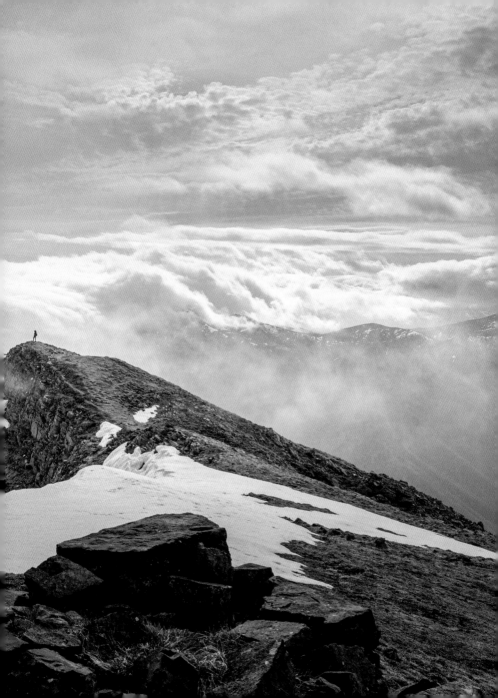

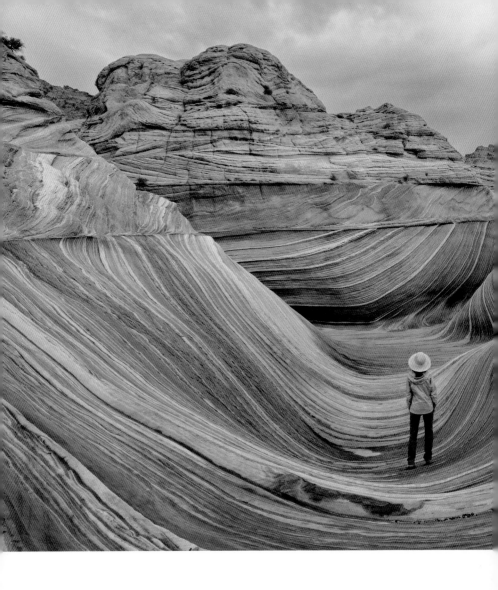

Coyote Buttes, Arizona, USA
36.9678° N, 112.0113° W

@DESERTMOON2020

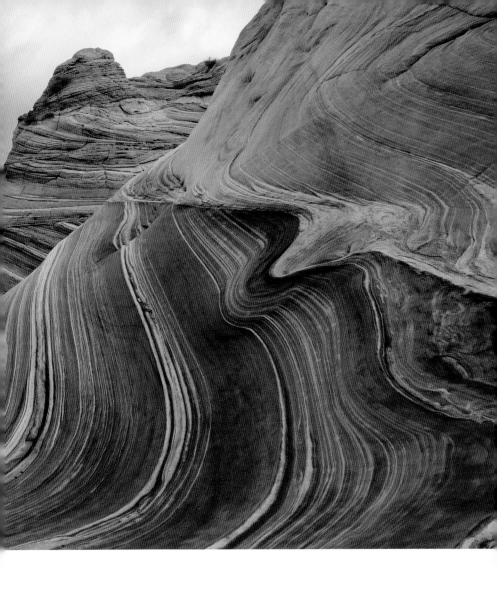

'May your trails
be crooked,
winding, lonesome,
dangerous, leading
to the most amazing
view. May your
mountains rise
into and above
the clouds.'

–Edward Abbey

Hussaini Hanging Bridge, Hunza, Pakistan
36.4238° N, 74.8826° E

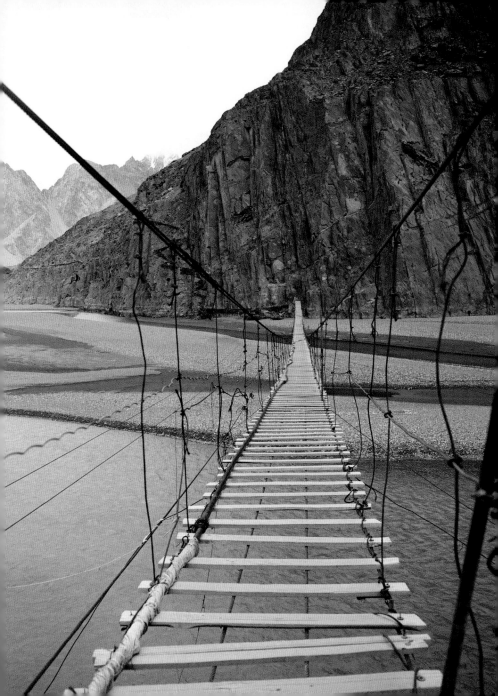

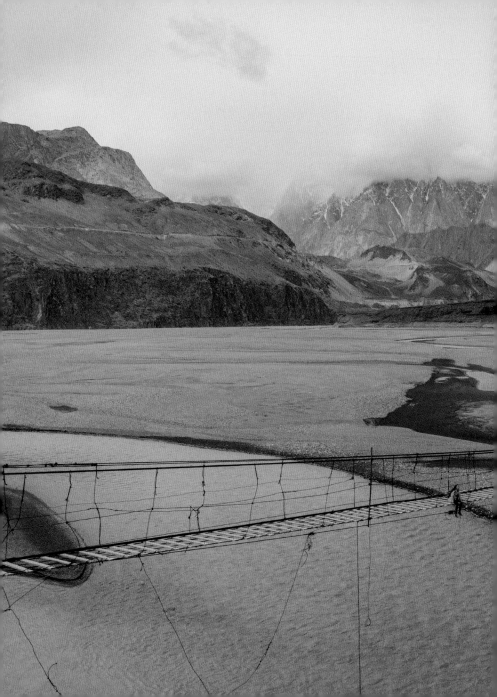

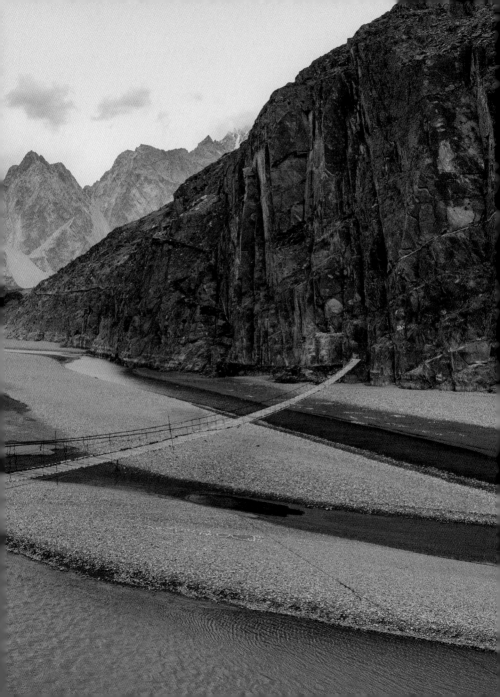

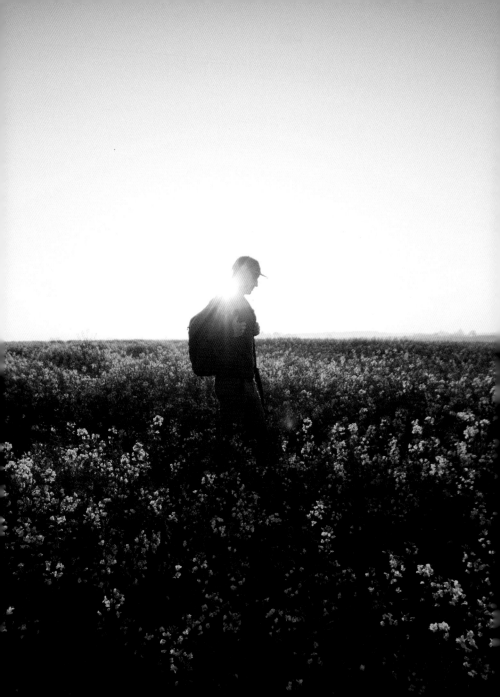

Ampthill, Bedfordshire, England
52.0273° N, 0.4951° W

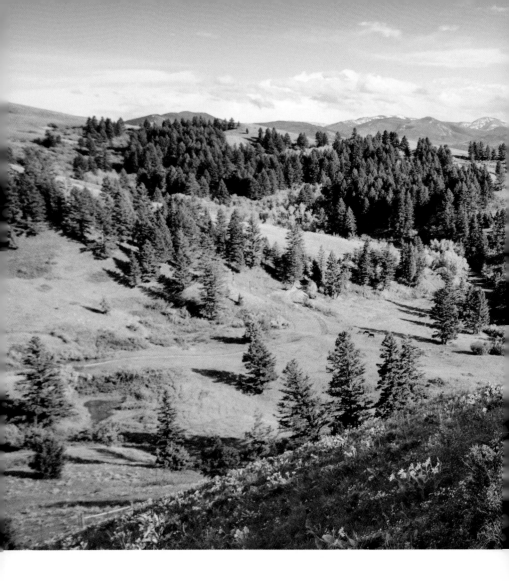

Bozeman, Montana, USA
45.6770° N, 111.0429° W

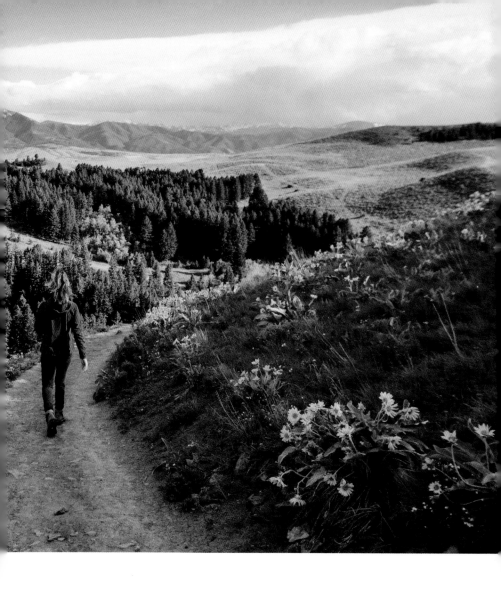

Three Rivers, California, USA
36.4388° N, 118.9045° W

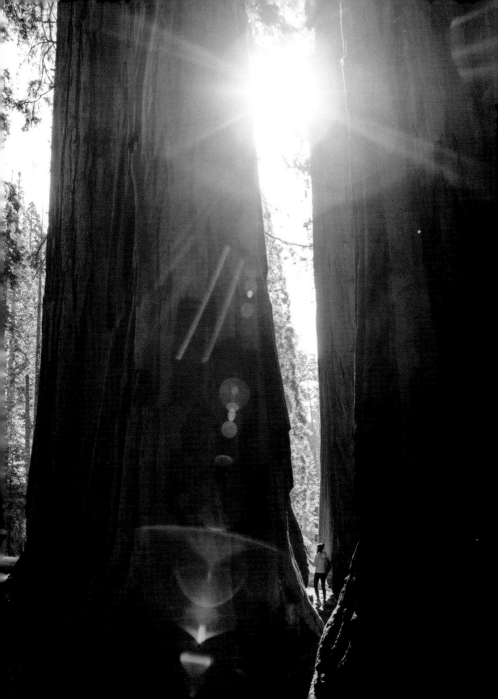

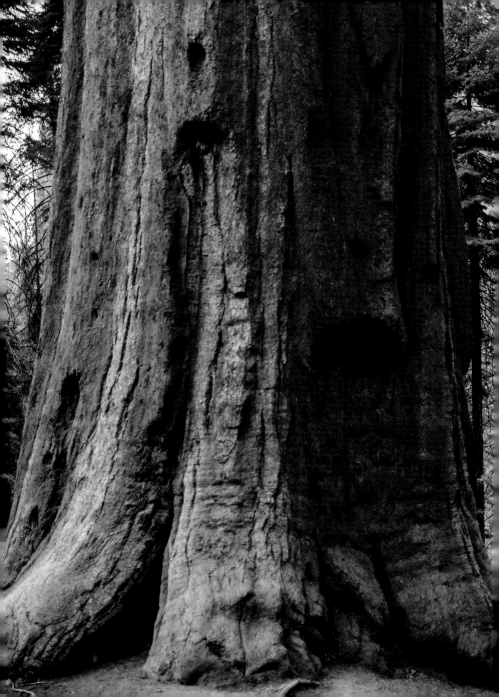

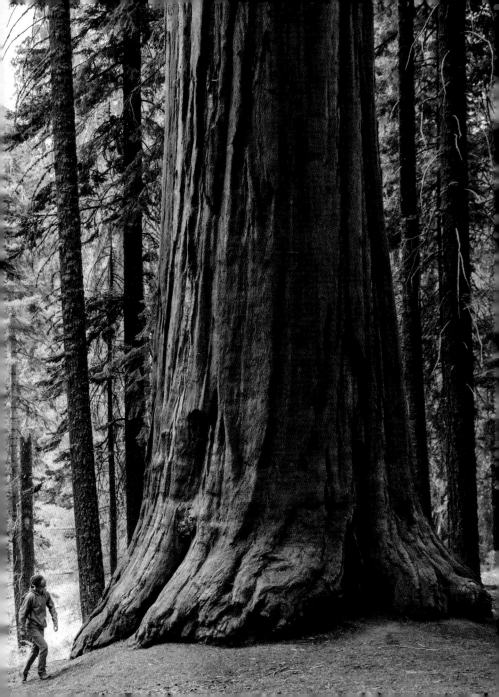

Mount Hood, Oregon, USA
45.3736° N, 121.6960° W

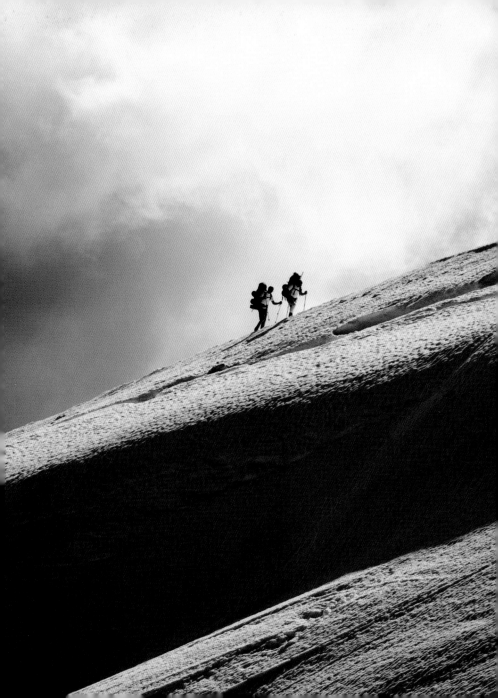

Moraine Lake, Banff National Park, Alberta, Canada
51.3217° N, 116.1860° W

@JORDAN_SIEMENS

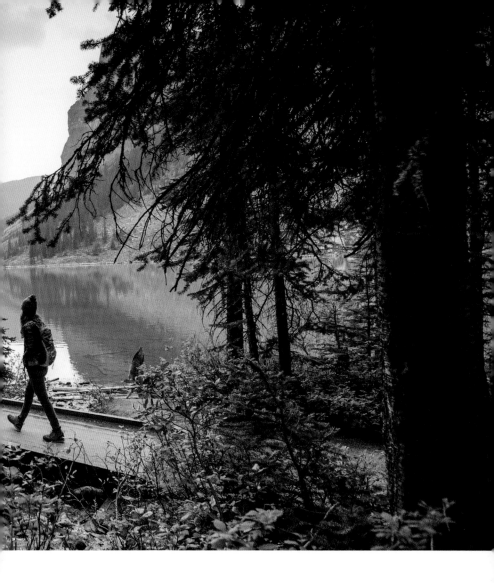

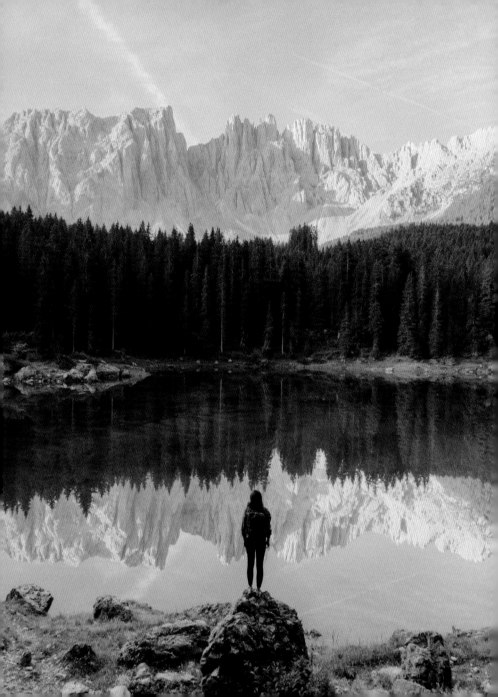

Karersee, South Tyrol, Italy
46.4092° N, 11.5751° E

@OLEHSLOBODENIUK

Tumpak Sewu Waterfall, East Java, Indonesia
8.2315° S, 112.9178° E

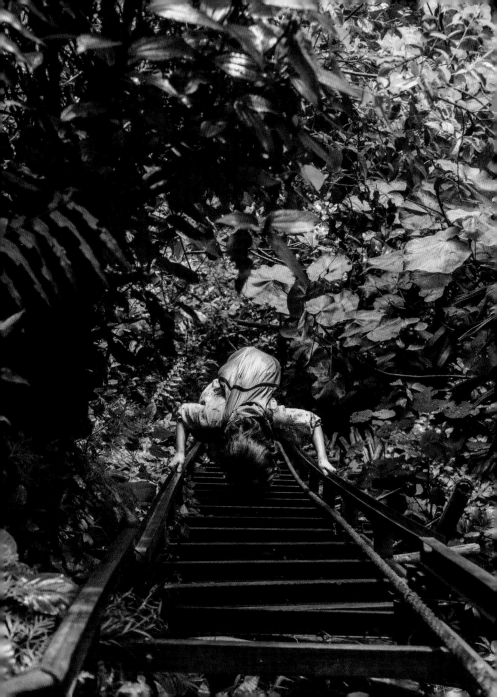

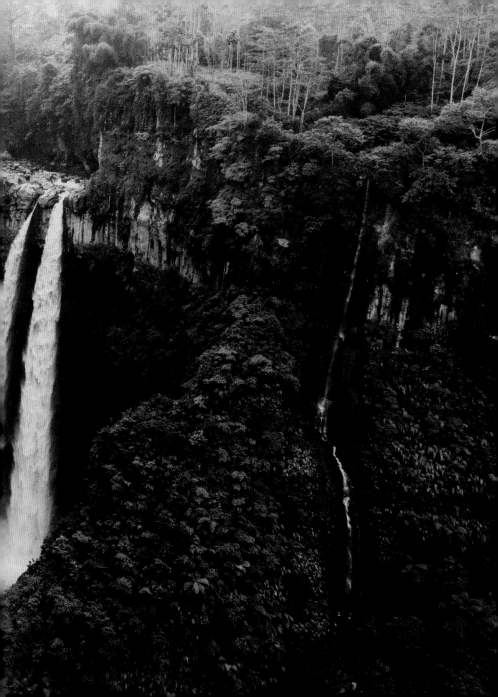

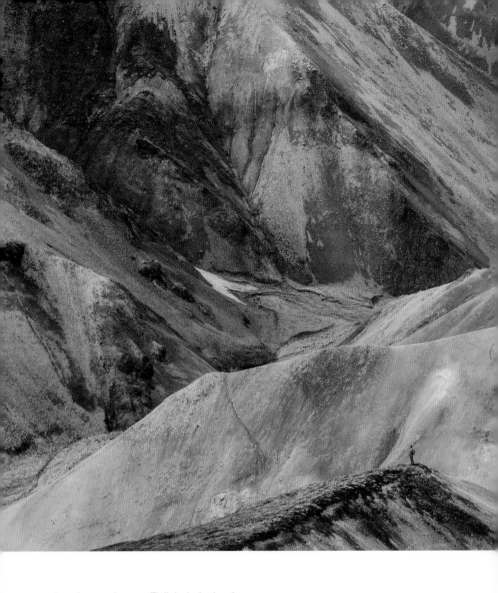

Landmannalaugar, Fjallabak, Iceland
63.9830° N, 19.0670° W

@OLEHSLOBODENIUK

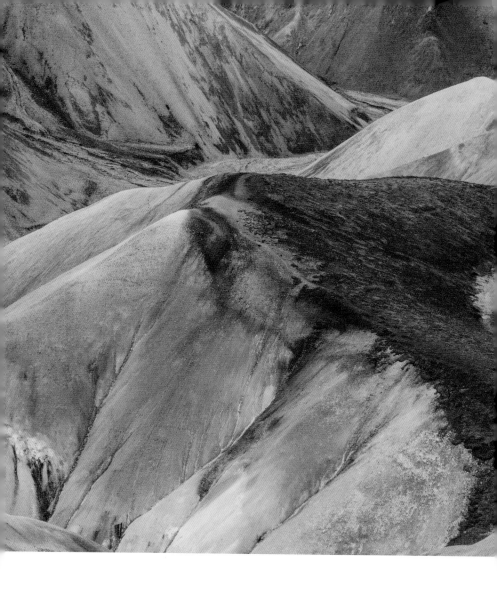

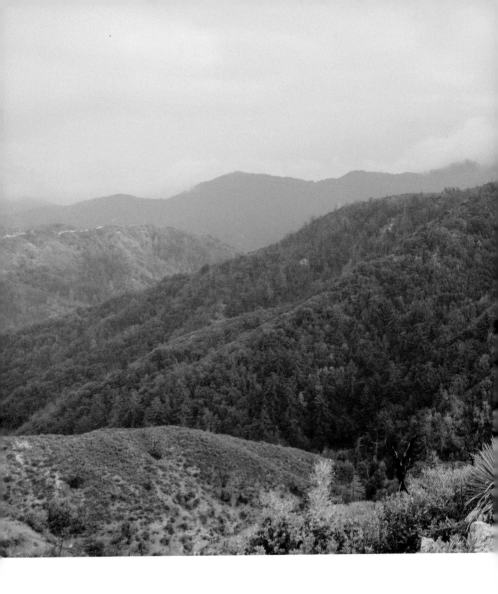

Angeles National Forest, California, USA
34.3168° N, 118.0058° W

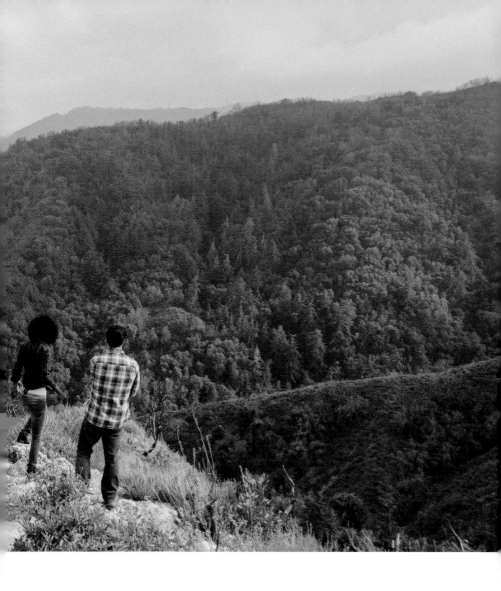

'I am never not thinking about nature, because I don't understand a way we can be honest about who we are without understanding that we are nature.'

–Camille T. Dungy

Velika Planina, Kamnik, Slovenia
46.3036° N, 14.6484° E

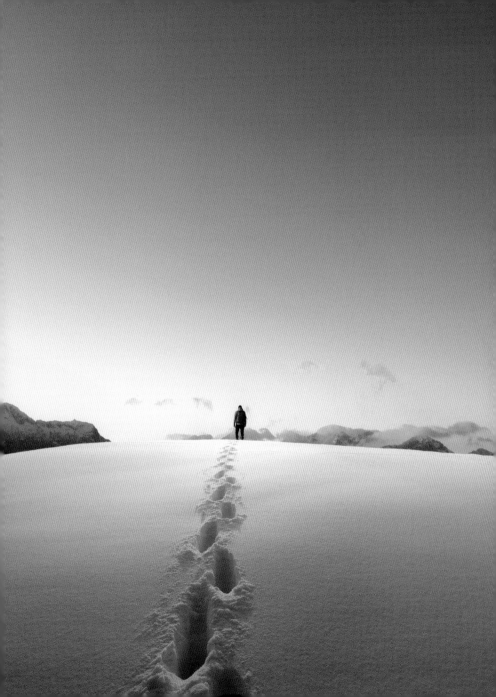

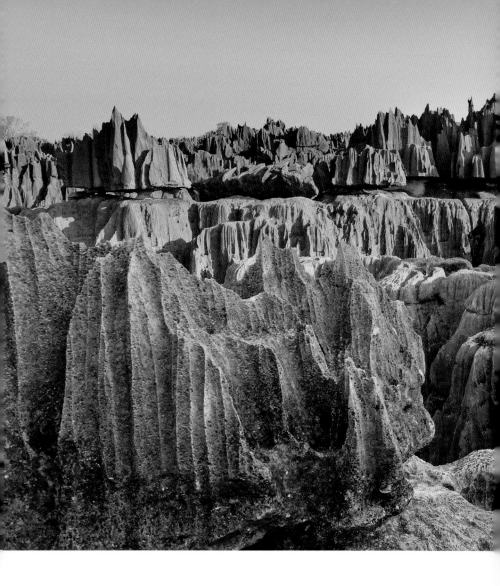

Tsingy de Bemaraha Strict Nature Reserve, Melaky, Madagascar
18.4369° S, 44.7381° E

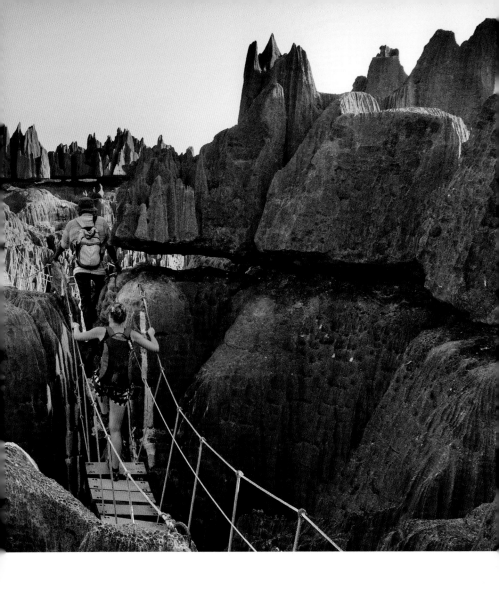

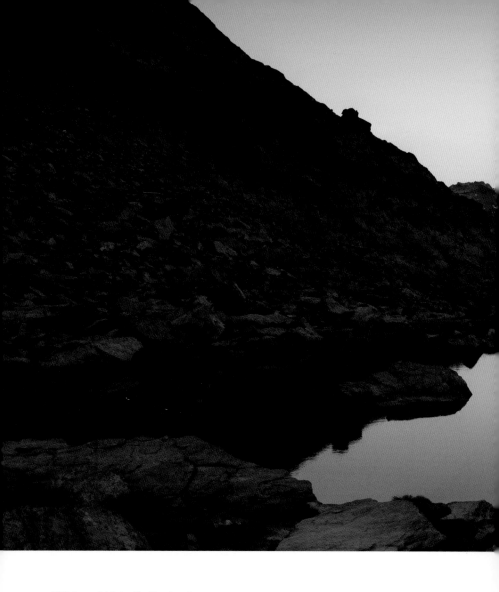

Riffelsee, Valais, Switzerland
45.9833° N, 7.7621° E

@SANDERVDW

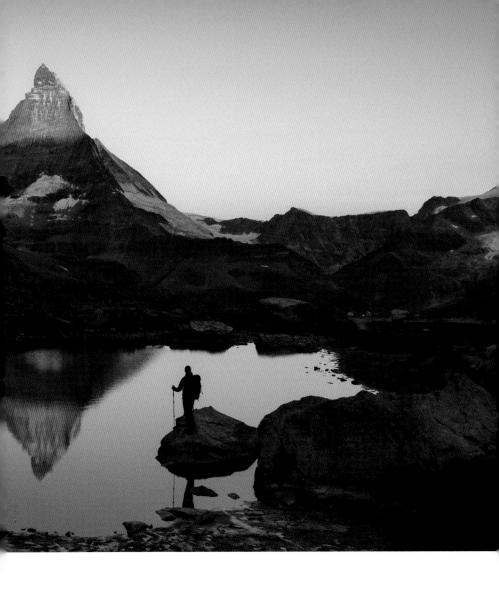

Maganik, Montenegro
42.7730° N, 19.2177° E

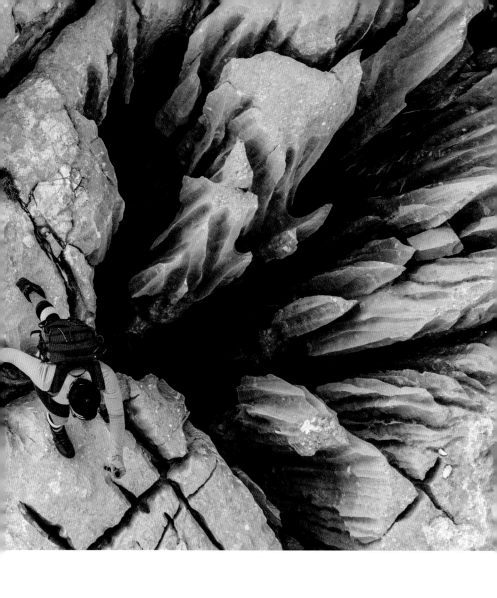

Filzmoos, Salzburg, Austria
47.4347° N, 13.5218° E

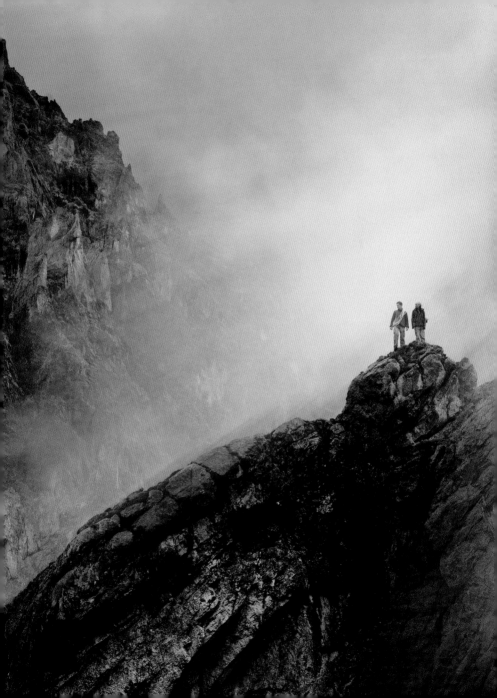

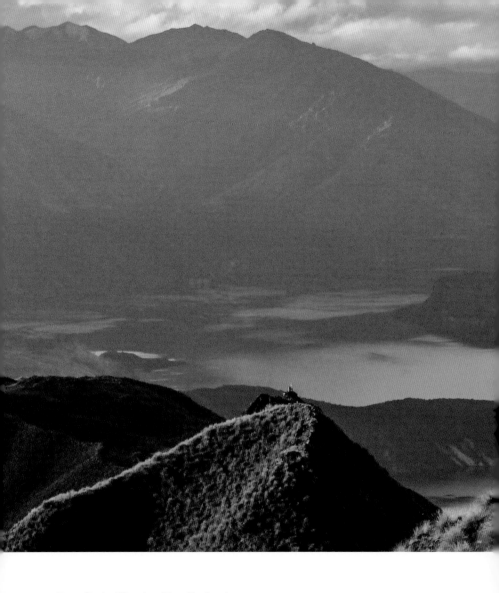

Roys Peak, Wanaka, New Zealand
44.7000° S, 169.0500° E

@AD_WILD

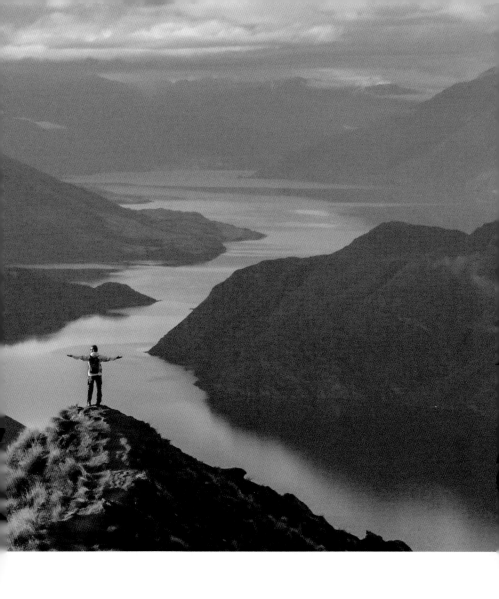

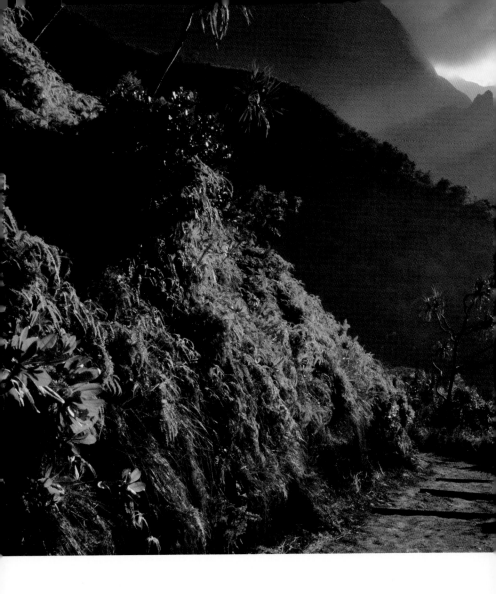

Kalalau Trail, Hawaii, USA
22.2002° N, 159.6188° W

CORINNE LUTTER

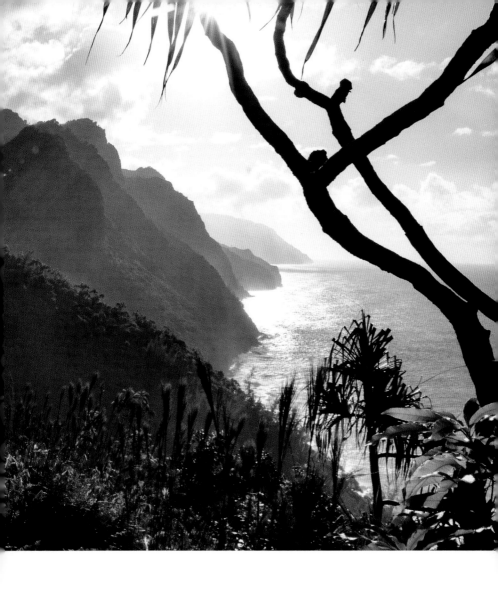

Interlaken, Bern, Switzerland
46.6863° N, 7.8632° E

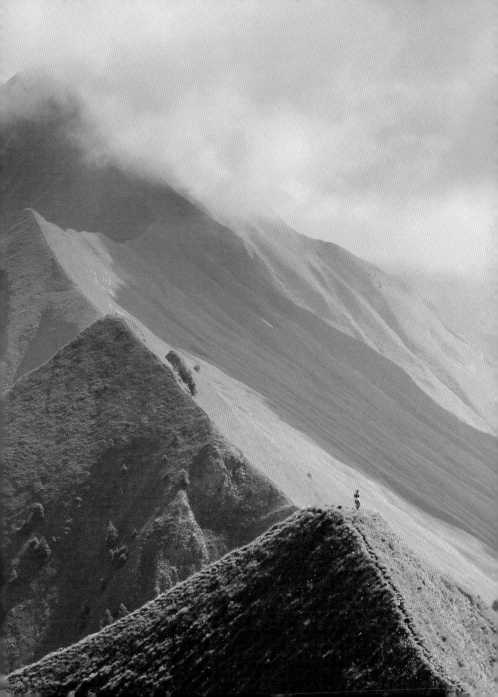

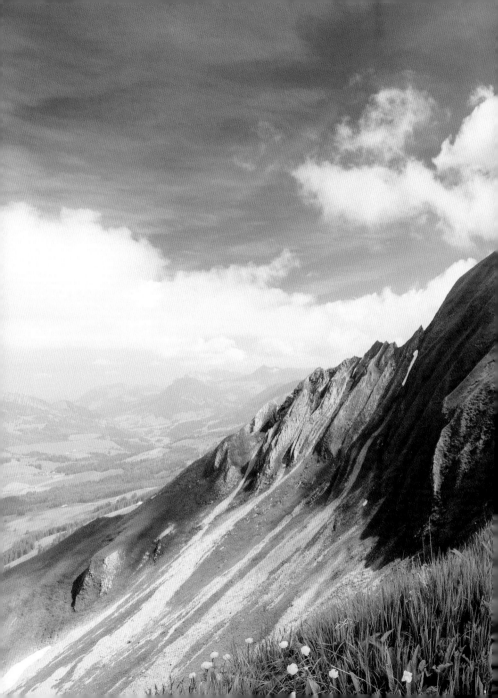

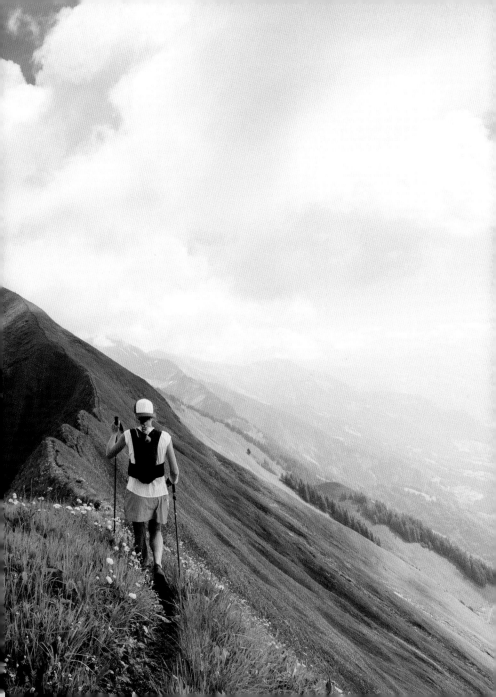

'Nature is not a place
to visit, it is *home*'

–Gary Snyder

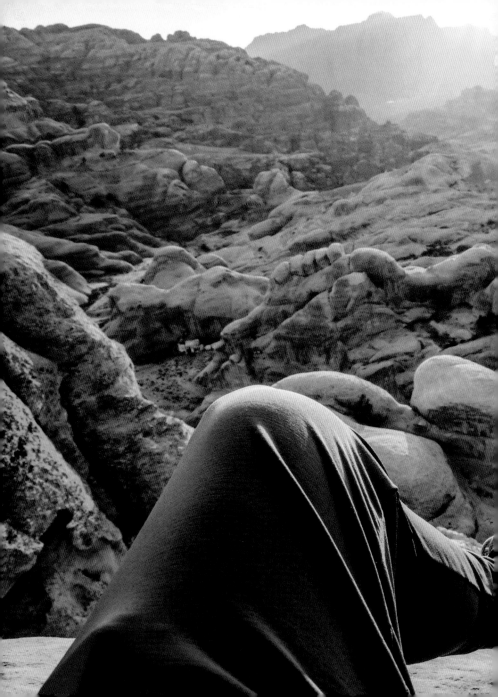

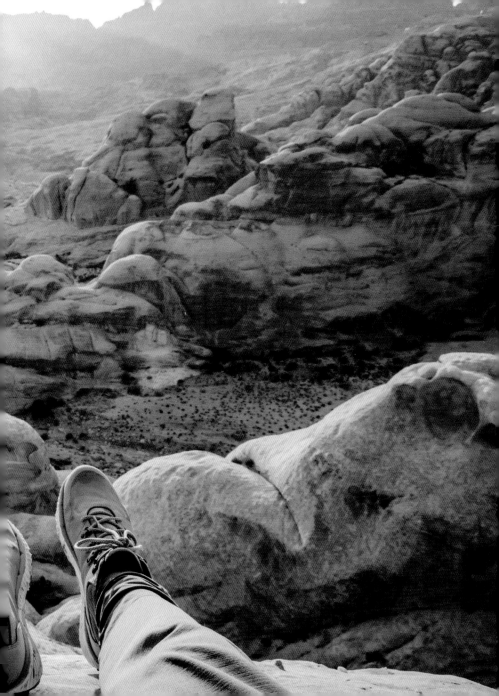

Index by Location

Index by Contributor

———

First published in the United States of America in 2022 by Chronicle Books LLC.

Produced and originated by Blackwell and Ruth Limited:
Publisher: Geoff Blackwell
Editor in Chief: Ruth Hobday
Design Director: Cameron Gibb
Designer & Production Coordinator: Olivia van Velthooven
Publishing Manager: Nikki Addison
Digital Publishing Manager: Elizabeth Blackwell
www.blackwellandruth.com

Captions

Front cover:
Karersee, South Tyrol, Italy
46.4092° N, 11.5751° E
@olehslobodeniuk

Front endpaper:
Dolomites, Trentino-South Tyrol, Italy
46.4102° N, 11.8440° E
@marcobottigelli

Pages 2–3:
Dolomites, Trentino-South Tyrol, Italy
46.4102° N, 11.8440° E
@marcobottigelli

Pages 204–5:
Petra, Ma'an, Jordan
30.3216° N, 35.4801° E
@arturdebat

Back endpaper:
Gesäuse National Park, Styria, Austria
47.5652° N, 14.5891° E
@ascentxmedia

Back cover:
Coyote Buttes, Arizona, USA
36.9678° N, 112.0113° W
@desertmoon2020

Printed and bound in China by 1010 Printing Ltd.

This book is made with FSC®-certified paper and other controlled material and is printed with soy vegetable inks. The Forest Stewardship Council® (FSC®) is a global, not-for-profit organization dedicated to the promotion of responsible forest management worldwide to meet the social, ecological, and economic rights and needs of the present generation without compromising those of future generations.

MIX
Paper from responsible sources
FSC® C016973

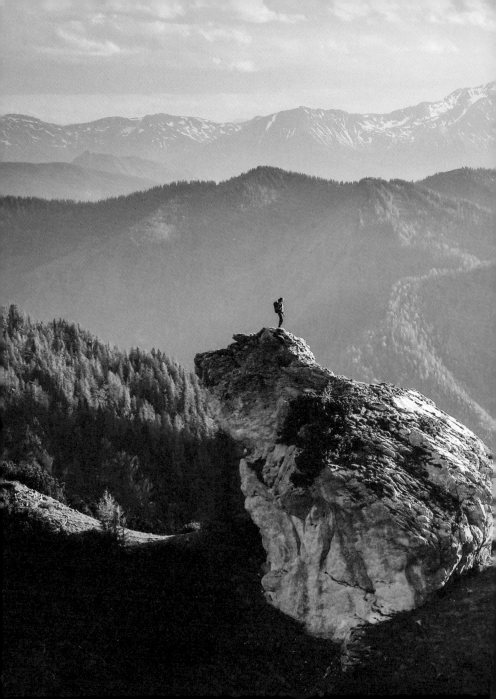